IMAGES
of America

THE BALLARD LOCKS

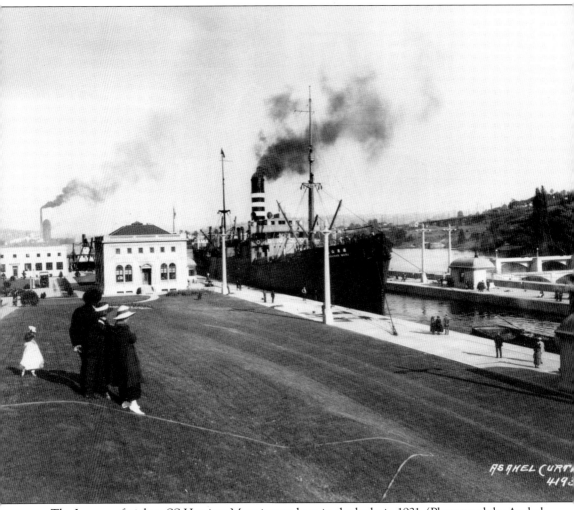

The Japanese freighter SS *Horaisan Maru* is seen here in the locks in 1921. (Photograph by Asahel Curtis; courtesy University of Washington Library Special Collections and Julie Albright.)

ON THE COVER: The Corps of Engineers' launch *Orcas* passes through the locks in 1916, prior to the facility's official opening. (Courtesy U.S. Army Corps of Engineers, Seattle District.)

IMAGES
of America

THE BALLARD LOCKS

Adam Woog

ARCADIA
PUBLISHING

Copyright © 2008 by Adam Woog
ISBN 978-0-7385-5917-9

Published by Arcadia Publishing
Charleston SC, Chicago IL, Portsmouth NH, San Francisco CA

Printed in the United States of America

Library of Congress Catalog Card Number: 2008926299

For all general information contact Arcadia Publishing at:
Telephone 843-853-2070
Fax 843-853-0044
E-mail sales@arcadiapublishing.com
For customer service and orders:
Toll-Free 1-888-313-2665

Visit us on the Internet at www.arcadiapublishing.com

For my family.

CONTENTS

ACKNOWLEDGMENTS

My primary thanks go to Dru Butterfield, natural resources manager, and Brian Carter, natural resources specialist, U.S. Army Corps of Engineers, Seattle District. Both were unfailingly generous with time, energy, loan of office space, and good-natured answering of pesky questions.

All photographs in this book are courtesy of the U.S. Army Corps of Engineers, Seattle District, unless otherwise noted. My deep appreciation goes to everyone who has helped over the years to preserve the locks' remarkable archives.

Thanks also to the following: my editor at Arcadia, Julie Albright, queen of the cheerful e-mails; my wife, Karen Kent, who said she believed me when I explained that hanging around at the locks, watching boats, was just research; our daughter, Leah Woog, who lent me her photographs for a bargain price; Jay Wells, visitor center program director, and Susan Connole and Brad Carlquist, visitor center staff, for sharing so freely and enthusiastically; Stu Witmer and Phil Roush, for arranging a memorable jaunt on the water; and *HistoryLink.org*, an invaluable resource for any Washingtonian curious about the state's past. A grateful tip of the hat goes to it and the spirit of its creator, the late—but clearly immortal—Walt Crowley.

Also helpful were Carolyn Marr, librarian of the Museum of History and Industry, Seattle; Mary Ann Gwinn, book editor of the *Seattle Times*; Louise Richards of the Fisheries-Oceanography Library, University of Washington; Richenda Fairhurst; Robert Fisher, collections manager of the Wing Luke Asian Museum; Tom Dean of the Boeing Employees' Concert Band; and Leslie V. Unruh and the Coal Creek Jazz Band.

INTRODUCTION

The Hiram M. Chittenden Locks, popularly known as the Ballard Locks, are an integral part of the waterways around Seattle, Washington. The locks are one of Seattle's top destinations for tourists and locals alike. Well over a million people every year come to watch salmon and other fish migrate through the fish ladder, visit the botanical gardens, and watch a nonstop parade of ships—from working vessels to pleasure craft—as they rise and fall through the locks. The locks are the busiest facility of their kind in America—more boat traffic passes through them than any other lock in the country.

The locks in total comprise approximately 17 acres, of which seven acres are devoted to botanical gardens. They are the heart of an eight-mile, man-made channel, the Lake Washington Ship Canal. This channel connects the saltwater of Puget Sound with the freshwater of Seattle's two major lakes, Lake Washington and Lake Union, lying to the east. Thanks to the development of Seattle and its suburbs, this system has become the state's most heavily urbanized watershed.

The westernmost section of the Ship Canal, where the locks are located and freshwater meets the sea, is Salmon Bay. Prior to the locks' completion in 1917, Salmon Bay was a tidal area navigable only by vessels with very shallow drafts. The locks raised and stabilized the bay's water level, ensuring that the area would become home to a large commercial fishing fleet, then and now centered at Fisherman's Terminal. In addition, dozens of marinas, repair shops, warehouses, dry dock facilities, and other water-oriented businesses in the watershed owe their existence to the locks. Among the large vessels able to moor in fresh water thanks to the locks are ships operated by the National Oceanic and Atmospheric Administration (NOAA) and stationed in Lake Washington.

Between the time of the locks' completion in 1917 and the 1930s, the facility was second in width only to the Panama Canal. They were the first of their kind constructed on the West Coast of the United States and are still the only locks on American territory capable of handling large oceangoing vessels. The locks are also the only facilities of their kind in the United States that separate fresh and saltwater and that accommodate tidal fluctuations. In 1978, they were added to the National Register of Historic Places.

The locks were built, and are still maintained, by the U.S. Army Corps of Engineers. Since its permanent establishment in 1802, the corps has been the nation's most prominent engineering organization. Starting in the era after the Civil War, the corps' civil works responsibilities increasingly overshadowed its military role.

The locks are officially named in honor of Hiram Martin Chittenden, who, as an engineer and a U.S. Army major, was the key figure responsible for their conception and design. The facility's popular name, the Ballard Locks, comes from the Seattle neighborhood just to the north. (The neighborhood to the south, high on a bluff, is Magnolia.) Once a separate town, Ballard was for decades dominated by maritime- and lumber-related businesses and was characterized by a heavily Scandinavian population. Today Ballard has a considerably more diverse mix of residents and businesses.

The locks serve three major functions. They maintain a steady water level for Lakes Washington and Union—typically 20.6 feet above mean low tide. They also prevent the freshwater of the lakes from mixing with the saltwater of Puget Sound. Of primary interest to the public, however, is the locks' third purpose: making it possible for vessels to rise or fall the 20 feet from one water level to the other.

An estimated 75,000 boats and ships pass through every year. Some of these vessels are working ships, such as log tows, commercial fishing boats, and barges for sand, gravel, or fuel. Others are pleasure craft, ranging from the smallest sailboats and kayaks to the most luxuriant of luxury yachts. This nonstop parade—the locks operate around the clock, 365 days a year—is an enduring source of pleasure for boat lovers.

The main part of the facility consists of two locks. The smaller of these is 30-by-150 feet, the larger 80-by-825 feet. The two-lock system's versatility has several advantages. The small lock can be routinely used when boat traffic is light and only smaller craft need to get through. This conserves fresh water during summer, when the levels of the lakes are lower. Meanwhile, the large lock is available to accommodate barges and other oversize vessels. (Non-motorized vessels, such as kayaks and canoes, always use the small lock.) Another advantage to the two-lock system is that the locks need never shut down. One can be drained for maintenance while the other remains in service.

There are several other key parts of the locks. Among these is a 235-foot spillway with six 32-by-12-foot gates. This spillway is used to control the water level of the canal and lakes by opening or closing the gates. Meanwhile, a fish ladder lets salmon and other fish migrate through the locks during certain seasons. A portion of this ladder features public viewing windows; along with the boat traffic, it is one of the lock's most popular spots for visitors. The locks also feature the Carl S. English Jr. Botanical Gardens, a popular destination for picnicking, strolling, plant viewing, and—when the season is right—attending free concerts. Further amenities include a visitor center and adjacent gift shop operated by the Northwest Interpretive Association, a nonprofit group dedicated to helping people learn about public land in the Pacific Northwest.

Admission to the locks is always free—it is one of the best entertainment values in town. The facility, including the gardens, is open to the public daily, year-round, from 7:00 a.m. to 9:00 p.m. The fish ladder's viewing room is open year-round from 7:00 a.m. to 8:45 p.m.

The visitor center and gift shop are also open year-round. Between October 1 and April 30, they are open from 10:00 a.m. to 4:00 p.m., closed on Tuesdays and Wednesdays. From May 1 through September 30, they are open between 10:00 a.m. and 6:00 p.m. daily.

Free, guided tours of the locks are available from March 1 through November 30. The visitor center (206-783-7059) can provide details on times and additional information.

One

THE EARLY DAYS

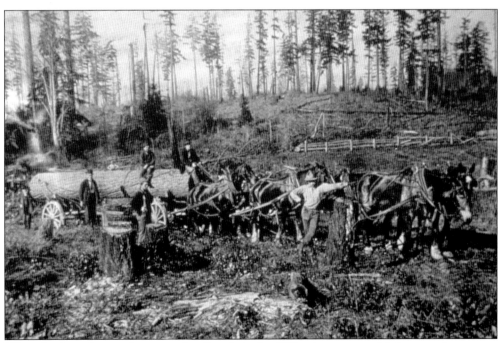

When the first white settlers arrived in Seattle in the 1850s, the area was rich in natural resources, particularly timber and coal. However, transporting these resources was cumbersome and slow. Just getting coal from the Cascade foothills to the Seattle depot at Elliott Bay, for instance, required 11 transfers from water to land and back again.

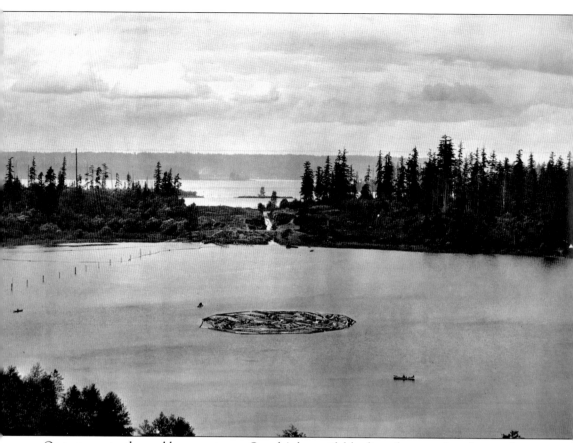

One answer to the problem was to use Seattle's bountiful bodies of water—its saltwater bays, freshwater lakes, rivers, and streams—for transportation. Connecting these bodies of water via man-made channels would vastly improve the movement of materials and resources. There were several other advantages to connecting saltwater with fresh. Freshwater wharves would make possible the loading of cargo at any time, not just at high tide. Ships moored in freshwater wharves would be less prone to rot. And lakefront shoreline, if easily accessible from the sea, would be available for industrial development. Connecting the region's natural bodies of water was proposed very soon after Seattle became a permanent settlement. One of the town's best-known pioneers, Thomas Mercer, publicly suggested it in 1854. During the new community's first Independence Day celebration, held on the shores of the lake called *tenas Chuck* in the Chinook trading jargon, Mercer proposed that a canal be dug connecting the region's two main lakes with Puget Sound. Mercer then renamed *tenas Chuck* "Lake Union," suggestive of a future union of these waters.

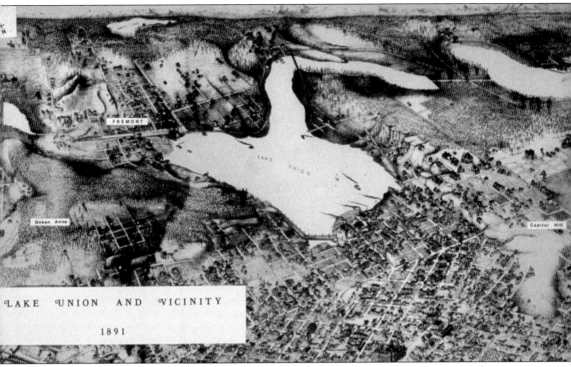

LAKE UNION AND VICINITY

1891

Despite setbacks, including the Great Seattle Fire of 1889 and a national depression, the region grew quickly. During the 1890s, Seattle nearly doubled in population to more than 80,000. The discovery of gold in the Yukon spurred growth, since Seattle was a major stocking-up and jumping-off point for hopeful prospectors. Also, the completion of a train line made Seattle far more accessible. Part of this growth was industrial development. For example, the mills of Ballard thrived, turning out 40 million feet of lumber annually in the early part of the decade. Ballard became the world's leading manufacturer of shingles. This 1891 map shows Seattle as it grew around Lake Union. The Lake Washington Ship Canal would eventually connect Lake Union (in the center of the map) with the much larger Lake Washington (to the east) and Puget Sound (to the west). However, situating the canal on this route was not a given. Seattleites have always been outspoken and contentious regarding transportation systems, and this was no exception. As the region grew, a number of possibilities were explored.

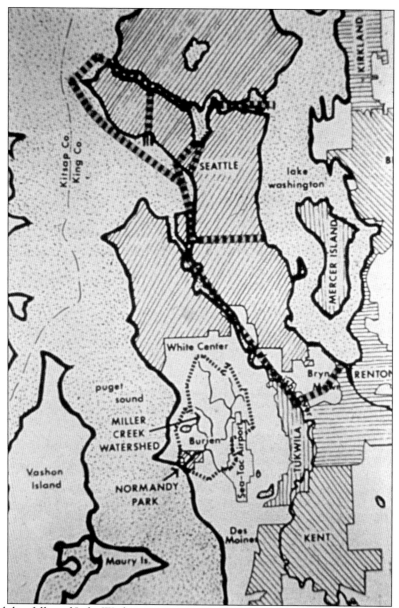

One possibility followed Lake Washington's natural outlet, south of what is now downtown Seattle. However, a canal along this route would have required constant dredging. Also considered was a route from Lake Washington to Smith Cove (the site of the present-day Elliott Bay Marina) in Elliott Bay. The Corps of Engineers favored this route, in part because it promised the greatest security from naval attacks. However, for some time, it did not actively pursue the matter, mostly because of a lack of support from government authorities outside the region. Furthermore, the influential owner of the Great Northern Railway, James J. Hill, objected to this particular route (it interfered with his plans). He favored the route that was eventually adopted. This map shows several contenders for the canal route. At top is the Lake Washington–Lake Union–Salmon Bay route (the one eventually chosen). The lines from the south end of Lake Union to Elliott Bay mark the so-called "Smith Cove" route. Below that, bisecting Beacon Hill, is the route of "Semple's Canal." And the southernmost route follows the natural outlet of Lake Washington.

"Semple's Canal" was named for the project's leader, former Washington Territory governor Eugene Semple. His plan seems outlandish today but was in keeping with the bold spirit of the times, which was not averse to dramatically reworking Seattle's geography. The idea was to dig twin waterways, each a mile long and 300 feet wide, from Lake Washington through the Rainier Valley to the mouth of the Duwamish River. This would have cut down the low point of the north end of Beacon Hill, roughly along what is now Dearborn Street, and essentially bisected the downtown. The tons of earth dug up would go into Elliott Bay to make its tide flats into usable land. Not coincidentally, Semple and his business associates owned much of that land. Below, this photograph from 1880 was taken from Pine Street, looking south along Second Avenue. The earth dug up from Semple's Canal would eventually fill the wide bay at the top of the picture.

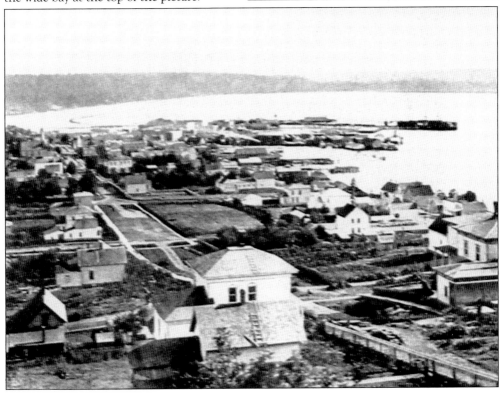

The group obtained financial backing and government approval, and work began in 1895. Within a year, 2,000 feet of waterway were dredged and 70 acres of tideland filled and ready for sale. But difficulties emerged, notably engineering obstacles, protests from displaced homeowners, and charges of shady arrangements with the city.

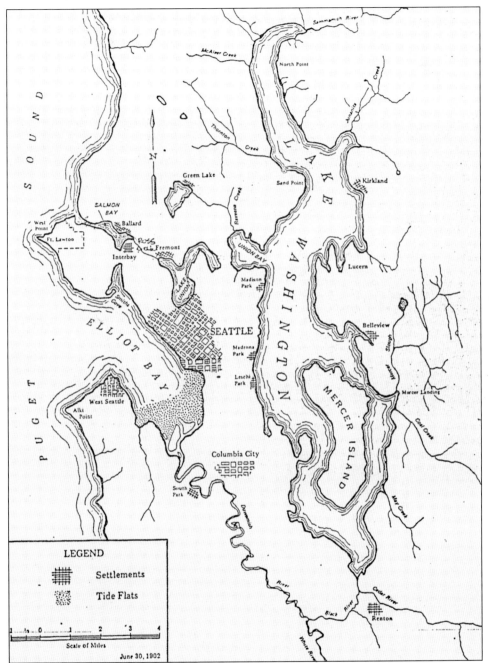

An engineering board commissioned by the corps in 1902 concluded that the plan had serious flaws. It wrote, "While the Board deems this route 'feasible' in the broad sense of that term, it considers that the difficulties and objections are so great as to make it almost impracticable as that word is ordinarily employed in business." In time, Semple's financiers pulled out, he resigned, and, in 1904, work stopped for good. There was, however, a silver lining to this ill-fated project: The filled-in tidelands later became Harbor Island and other areas of Seattle's industrial heart. This can be seen as the tide flats south of downtown Seattle in this 1902 map, prepared by the Seattle District of the U.S. Army Corps of Engineers for its annual report.

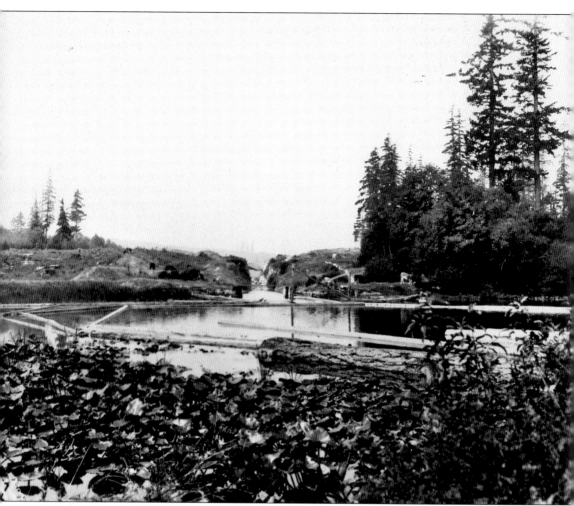

Meanwhile, a rival canal project was underway along the route that eventually became the Lake Washington Ship Canal. The plan was to create a channel just wide enough to float logs through. The work had begun in the 1860s, when Harvey L. Pike tried to dig a ditch with pick and shovel between Portage Bay and Union Bay (the closest points between Lake Union and Lake Washington). Among his reasons was that he hoped to increase the value of land he owned along the route. However, the project was too much for one person, and Pike abandoned it. The next major event came in the early 1880s, when the Lake Washington Improvement Company was organized to complete the route. Many of the businessmen among this group will be familiar to students of Seattle history, including Thomas Burke, Daniel Gilman, and Harvey Pike. A number owned property along the lakeshores and so stood to gain financially from a completed channel. The route also met with the approval of the Great Northern Railway's Hill, and it was the second choice of the Corps of Engineers.

Work progressed fitfully, but by the late 1880s, a functioning canal, wide enough to float logs west to the lumber mills of Ballard, was complete. Part of this narrow channel connected Lake Union and Lake Washington along the route begun by Pike. This 16-foot-wide passage, known as the Portage Canal, had a crude lock system that included a spillway to minimize damage to the locks from floating timber.

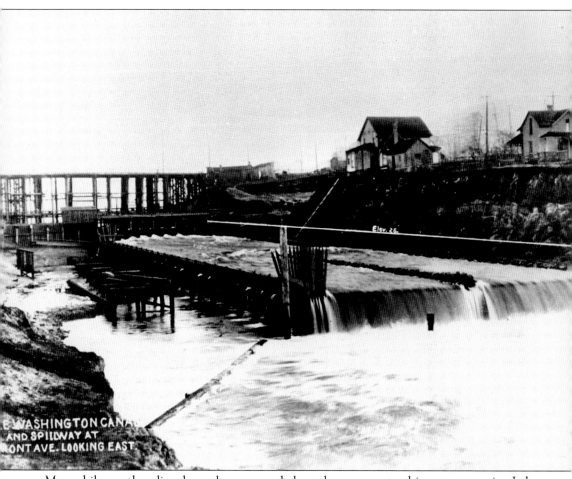

E WASHINGTON CANA
AND SPILLWAY AT
ONT AVE. LOOKING EAST

Elev. 26.

Meanwhile, another slim channel was opened along the same route, this one connecting Lake Union with Salmon Bay (which in turn fed into Shilshole Bay and Puget Sound). This undated photograph shows the spillway and small wooden lock at Fremont Avenue, to the east of the present locks in the Fremont area.

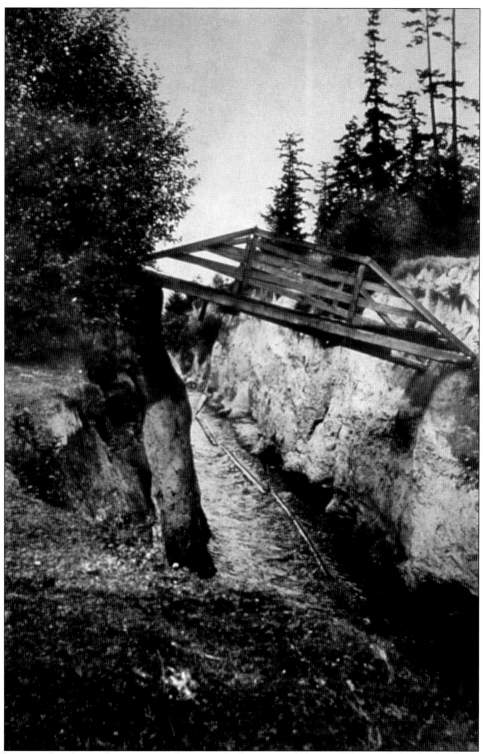

This completed a modest waterway between freshwater and the sea. The rough footbridge formed a precarious span over the canal.

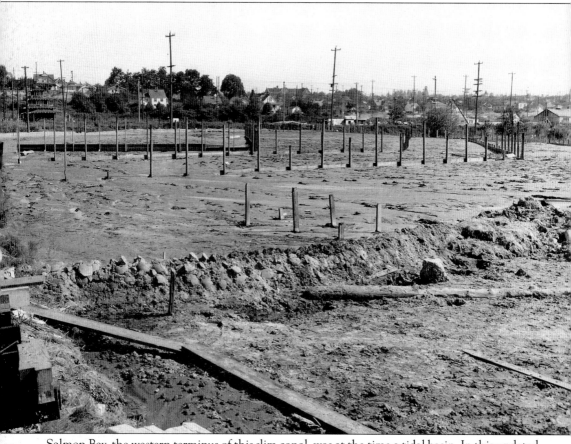

Salmon Bay, the western terminus of this slim canal, was at the time a tidal basin. In this undated photograph, the tidal flats have been marked for some purpose, perhaps for future docks.

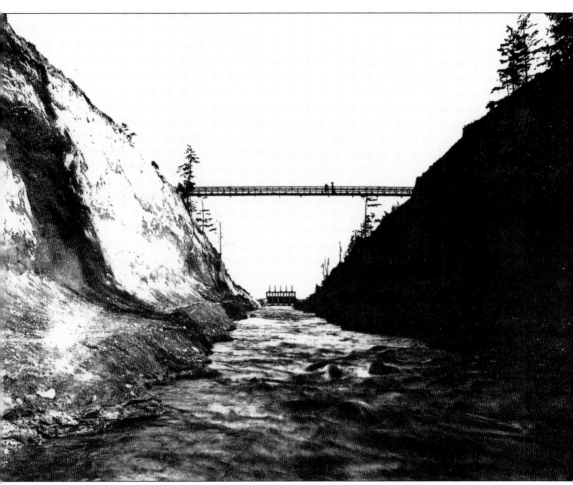

A group of about 25 Chinese laborers performed the actual construction of this first channel. Wa Chong, one of the first Chinese-run businesses in Seattle, hired the workers. Writing in 1973, *Seattle Times* reporter Don Duncan noted, "These men, frequently treated like the dirt they removed, accomplished more than anyone else until the Army Corps of Engineers and private contractors moved in with heavy equipment years later. And the Chinese did it with the most rudimentary tools. . . . There are no monuments to [these] men. There should be." Alas, no photographs are known to exist of this group of anonymous laborers.

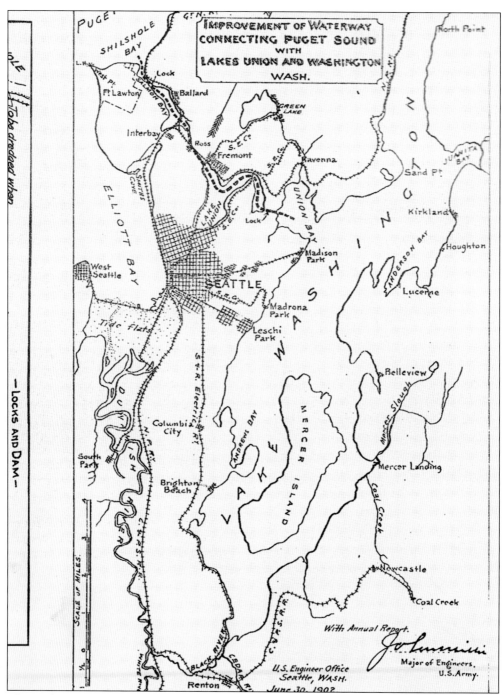

The modest channel was suitable for logs but not much more, and plans soon surfaced for a grander canal along this route. Note, on this 1902 diagram, the location of the future Ballard Locks. A planned second lock at the east end of the canal, visible here, was eventually scrapped.

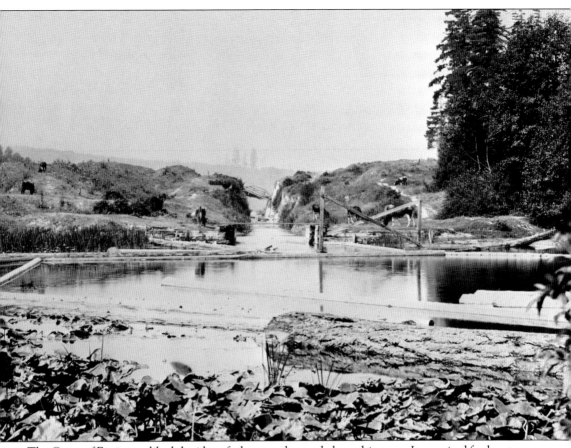

The Corps of Engineers liked the idea of a large-scale canal along this route. It promised freshwater anchorage for navy ships as well as easy access to timber and coal for their stores. The corps conducted surveys and made recommendations, but things moved slowly, in part because the Seattle District office could not drum up support from back east (outsiders called it "Seattle's ditch") and in part because various groups of Seattle locals were still arguing over the channel's exact location and size. As it happened, the wrangling took so long that the navy finally decided to build its base not on Lake Washington but in Bremerton, across Puget Sound. Discouraged, private citizens tried to step in. In 1906, an engineer and entrepreneur, James A. Moore, proposed a canal with two wooden locks, suitable for small ships.

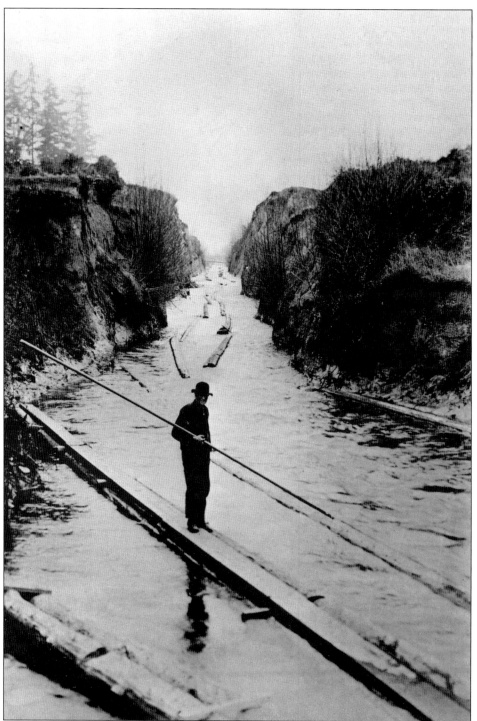

Moore hoped for funding of $500,000 from the county for his project. However, the corps found Moore's planned channel too narrow and his budget too small. The corps also worried that wooden locks would deteriorate quickly and that the second lock would create a flood danger for the land at the south end of Lake Washington.

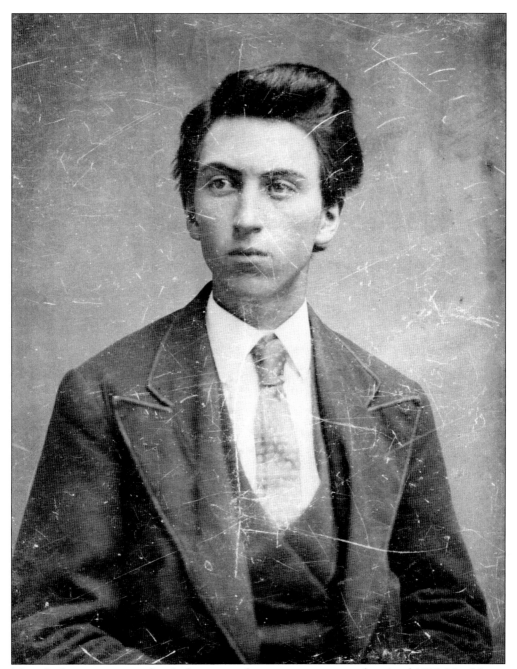

Moore's plan was moving ahead when a new district engineer arrived in April 1906. Maj. Hiram Martin Chittenden would become the single most important person in the creation of the Ballard Locks. Chittenden was born in 1858 near Ithaca, New York, and a graduate with high honors of West Point. (This photograph was taken at about age 18.) When he arrived in Seattle, the engineer had already been key in a number of important projects, including the road system for Yellowstone National Park and flood control projects along the Ohio River Basin and the Sacramento River in California. Chittenden was also an author; his books included a history of the fur trade in the West and a history of Yellowstone.

Chittenden was not at all pleased with Moore's plan. He felt the proposed channel was too narrow and the budget unrealistically low. Furthermore, he felt a wooden lock would deteriorate quickly and present a serious threat. He later wrote that it "would surely have collapsed sooner or later and precipitated Lake Washington into Puget Sound." Pictured here are Chittenden's parents, William and Mary Chittenden, and his sister Ida Lansing in 1919.

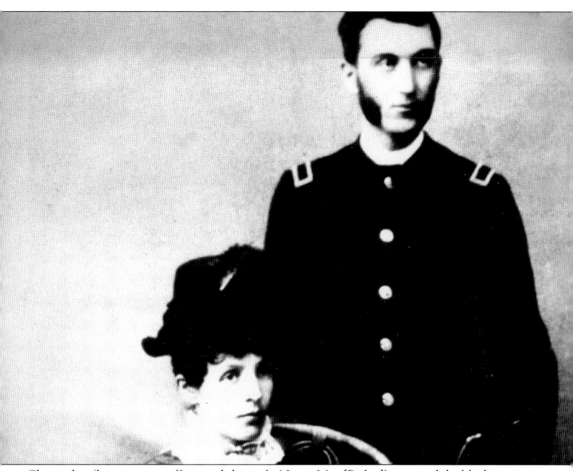

Chittenden (here a young officer with his wife, Nettie Mae [Parker]) proposed dual locks, one large and one small. He believed that most of the traffic would be tugs and other small boats rather than large ships. Sending most of the traffic through a small lock would be a considerable savings. He wrote, "The smallest boat that may pass a lock . . . requires nearly as much time and just as much power and water as to pass the largest vessel that the lock will take, and to use a great lock for such small craft must necessarily be a large source of waste." He also advocated using concrete to build the lock, creating a wider canal, and scrapping the lock at the eastern end of the canal. Eliminating this second lock would lower Lake Washington to the level of Lake Union and reduce flood danger; it was also prudent financially, since it significantly reduced the overall budget.

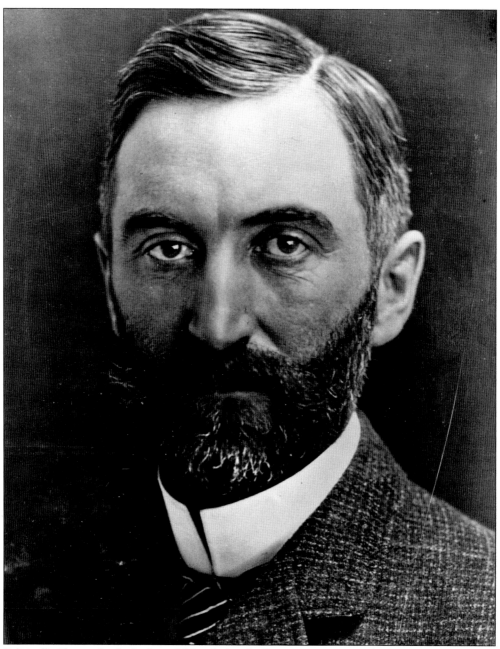

Politically Chittenden had a formidable job ahead of him. Moore's project had strong local support, and the major was wary of making his feelings known publicly. Instead, he quietly cultivated close personal relationships with community leaders. In part, he accomplished this by taking them out for boat rides. During these cruises, Chittenden would press home his concerns about Moore's plan. He later wrote, "I thus spread a leaven of doubt as to the whole scheme."

THE LAKE WASHINGTON CANAL

WHAT IT WILL MEAN TO THE PEOPLE

By GEN. H. M. CHITTENDEN
United States Army, Retired

Formerly in Charge of Government Engineering in this District

CHAMBER *of* COMMERCE, SEATTLE

The opportunity is now before the people of Seattle and King County to obtain the great harbor improvement for which progressive citizens have hoped and labored for nearly a score of years. The river and harbor bill, which became a law on June 25, 1910, authorizes a government contract in the sum of $2,275,000 for the construction of locks for the Lake Washington canal, provided that the secretary of war shall be satisfied that King County or other local agency will excavate the channel and protect the United States from damage. It is now for the local community to do its share so that the canal may be completed within three or four years.

The canal project contemplates a channel twenty-five feet in depth, seventy-five feet wide on the bottom and from 125 to 150 feet wide at the water's surface from Puget Sound to deep water in Lake Washington. From deep water in the sound for almost a mile in to the lock site at the Narrows, the channel will be enclosed between two breakwaters, 250 feet apart, which will furnish vessels or log rafts perfect protection from heavy weather.

Lock to Be Double.

The lock will be a double structure, containing one chamber large enough to pass the largest ships that may be expected to visit Puget Sound, and the largest log rafts commonly in use, and a small chamber designed to accommodate the mosquito fleet, pleasure craft, row boats, etc. The large lock will be one of the greatest structures of its kind in the world, exceeded in size only by the locks of the Panama Canal. Its total available length between gates will be 825 feet, and its width eighty feet. It will take in at mean lower low tide a vessel drawing thirty feet; at and above mean sea level it will pass a ship drawing thirty-six feet. The operation of the lock will be very rapid. Twenty to thirty minutes only will be consumed in passing through the large chamber, and through the smaller chamber not more than ten or fifteen minutes.

The lock will make a deep fresh water basin of Salmon Bay with its surface raised to the level of Lake Union, and Lake Washington will be lowered to the same level by an open channel to be dug between the lakes, thus creating one immense non-tidal inner harbor with a shore line of eighty-five miles in length, affording magnificent facilities for wharfage and for factories and industrial plants.

Advantages of Canal.

By the lowering of Lake Washington, Cedar River will be turned into the lake instead of flowing into the Black and Duwamish Rivers. The floods in the Renton District will be obviated and extensive flats now subject to overflow will be made available for industrial sites.

The flood volume of the Duwamish will be reduced by more than 30 per cent and the problems of the proposed Duwamish waterway will thus be greatly simplified.

Floods will be entirely eliminated in the Sammamish Valley and a large area of level land reclaimed for manufacturing sites and for intensive agriculture.

The swamps which now constitute a nuisance at various points along the shores of Lake Washington will be drained, and converted into fertile meadows or into favorable sites for residence or industrial uses.

The annual fluctuation in the surface of the lake, sometimes amounting to nearly seven feet and causing great inconvenience and loss, will be obviated, as under the new conditions the variation will be insignificant and never exceed two feet. With a constant surface level, the lake shores can be utilized and beautified to a degree impossible with the present fluctuation.

The inflow of the Sammamish River at the north end of the lake and of the Cedar River at the south end, with the augmented canal outflow half way between, will insure the best sanitary condition of the water by creating a current to carry such surface drainage as cannot be cared for by trunk sewers.

Cheapen Cost of Supplies.

One of the greatest benefits from the canal—one which will come directly home to the people—will be the saving in drayage cost. Lake Union will become a great central dock and other docks will be established on Salmon Bay and at certain points on Lake Washington. Much hauling over steep hills will be done away with. At least 50 cents per cubic yard will be saved on the cost of delivering gravel, sand, coal and other material to a large portion of the city and county.

The saving to our people in having commodities brought almost to their doors by water will exceed each year $750,000, the amount of the proposed bond issue to excavate the canal.

For Business and Pleasure.

An allied consideration is the great value for the recreation of the people by the connection to be established between salt water and the lakes. These waters will become not only arterial highways for launches and power boats distributing freight and taking produce to market, but water boulevards as well for pleasure boating. The lakes will also prove highly serviceable for the accommodation of the fishing industry. The codfish fleet, the salmon carriers and the great number of power boats engaged in salmon and halibut fishing will be encouraged to outfit here and center their operations from this port.

Make Seattle Rendezvous.

Both as respects pleasure cruising and the operations of freighters and fishing boats, the advantage of free entry into these lakes as a fresh water harbor will go far to make Seattle the focal point for power craft in the whole great system of protected waterways formed by Puget Sound and the inland passages along the coast of British Columbia and Alaska.

The economies of a fixed water level in loading vessels are too obvious to require detailed discussion. To argue that they are of no account is to confess either ignorance or a partisan purpose of contending for what one knows is not true.

Freedom from the teredo is an immense advantage of a fresh water harbor. Piling and other wooden construction, unless specially treated at great expense, has but a short period of usefulness where it is subject to the

He soon succeeded in convincing influential leaders to change their minds, and Moore was persuaded to transfer his rights to a joint private-public concern. Meanwhile, Chittenden was also successful in gathering support for his project in Washington, D.C. After years of wrangling and indecision, the federal government was finally poised to build a canal along the route.

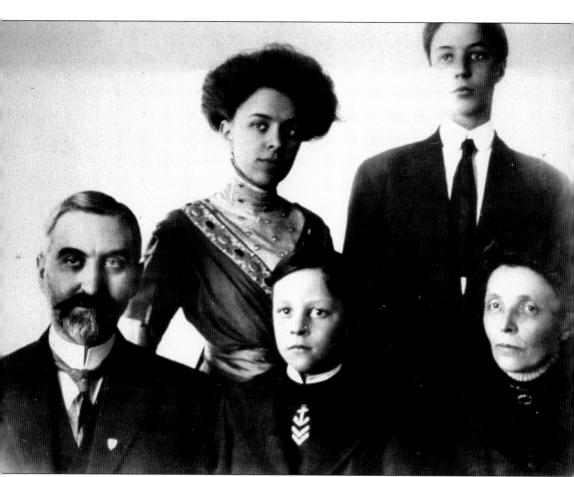

In addition to his strong feelings about safety, cost, and practicality, Chittenden, shown here with his wife and children, (clockwise) Eleanor Mary (b. 1892), Hiram Martin Jr. (b. 1894), and Theodore Parker (b. 1901), had a very personal reason for opposing Moore's plan. Completing the locks project to his satisfaction was personally an important milestone for him. It would be a suitable cap to a distinguished career. He wrote, "I knew this would be my last assignment with the Corps, and I knew the lock and canal was the most important project at hand, so I was determined to complete it as my final achievement."

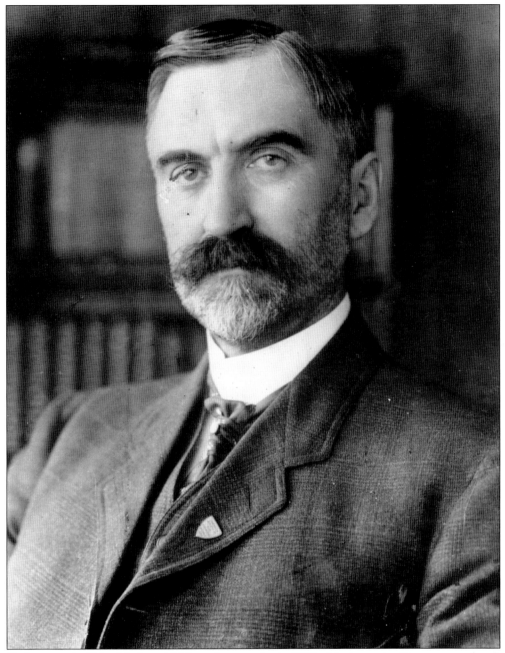

Unfortunately, ill health forced Chittenden to retire in 1909 with the rank of lieutenant colonel. With his formal retirement in 1910 came a promotion to brigadier general. As his health permitted, Chittenden remained active as a consulting engineer, Seattle port commissioner, and writer until his death in October 1917. He lived just long enough to see others complete the grand project he had devised.

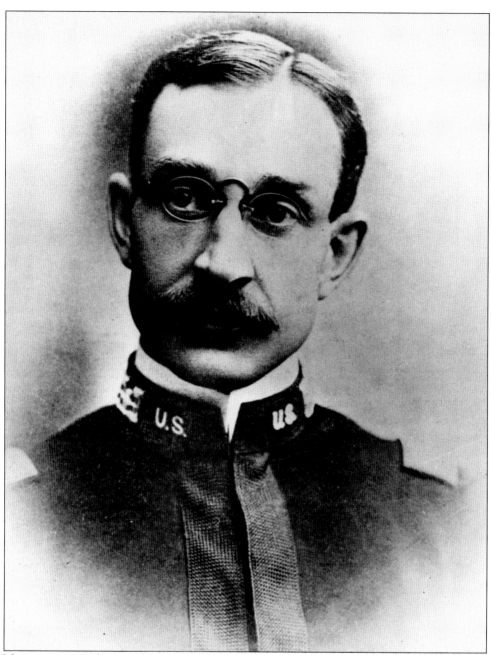

Of course, many other people were also key to the project in its earliest stages. One of these was Capt. Harry Taylor (pictured), who surveyed Lakes Washington and Union for the Army Corps of Engineers. Others included Arthur W. Sargent, who was the assistant engineer in charge of construction of canal, locks, and dam; Charles A. D. Young, a designer of the locks and dam; and Charles H. Bebb and Carl F. Gould, the deans of the Seattle architectural community and the designers of the project's support buildings. The budget for the revised project was now set at $4.5 million (in 1908 dollars). Roughly a third of this money was slated to come from local sources, the rest from the federal government. The board of engineers in Washington, D.C., formally approved Chittenden's proposal in March 1908, and work on the enormous project could at last begin.

BALLARD SHINGLE MILLS
LARGEST IN THE WORLD

The new plans for the canal took into consideration a number of factors. Among the primary ones was the ever-increasing size of ships destined to pass through. As a result, it was decided that the new locks would be nearly 800 feet long (twice the initially proposed length) and 100 feet wide. They would be dredged deep enough to be capable of handling ships with 30-foot drafts. However, even as the nuts and bolts of the revised plan were put in place, there were more delays. Chittenden's immediate successor, Maj. Charles W. Kutz, allowed various disgruntled citizens to revive the long-standing dispute over the exact location of the locks. The objections came mostly from mill owners in Ballard, which had grown considerably and now boasted the largest production of shingles in the world. The mill owners stood to lose property values if the locks were placed at the western end of Salmon Bay because it would raise the water's level in the bay.

The matter slowly underwent an appeals process. Not until June 1911 did Congress determine that construction of the locks could finally begin. After that, things proceeded relatively quickly and smoothly. The project was under the direction of Maj. James B. Cavanaugh (pictured). Cavanaugh was born in Illinois shortly after the Civil War. He graduated from the U.S. Military Academy in 1892 at the head of his class and was commissioned into the corps as a second lieutenant. Having reached the rank of major, Cavanaugh became Seattle district engineer in 1911 and supervised the completion of the locks project. After the opening of the locks, Cavanaugh continued his distinguished career with the corps, retired with the rank of colonel in 1922, and died in 1927. Cavanaugh House, the official residence of the Seattle district engineer, is named in his honor.

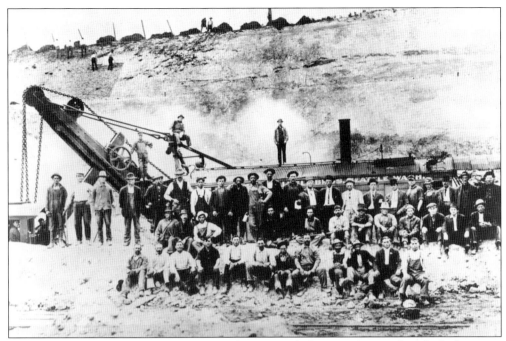

Ground was broken on September 1, 1911. About 10 weeks later, work started on the locks proper and the accompanying canal. It was a massive undertaking. Enormous amounts of dirt and rock had to be dug up and removed using high-pressure water and other methods. All told, an estimated 300 men worked on the construction of the locks. While there were several injuries, no deaths were associated with the building project.

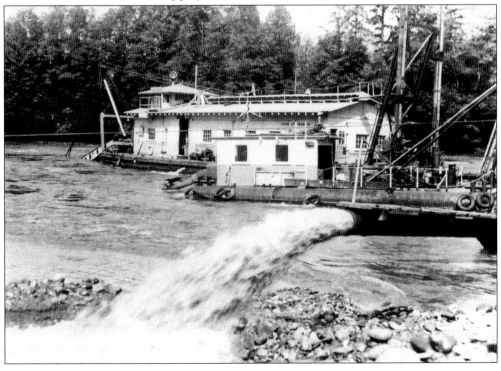

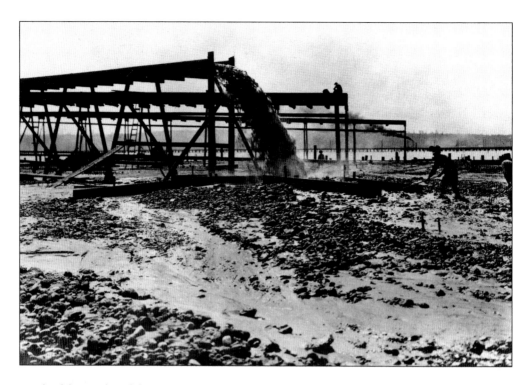

Much of the muck and dirt that was dredged out to dig the project was simply discarded. However, it was not wasted. It would find a purpose later—as the topsoil for the gardens planted on the north side of the locks.

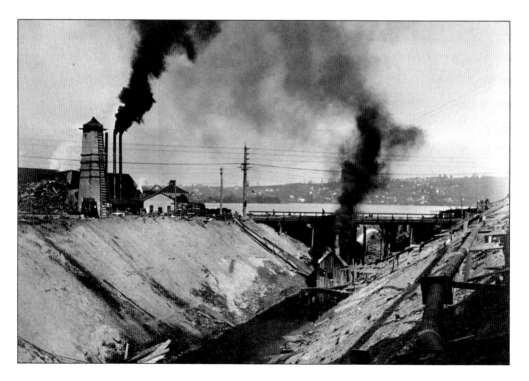

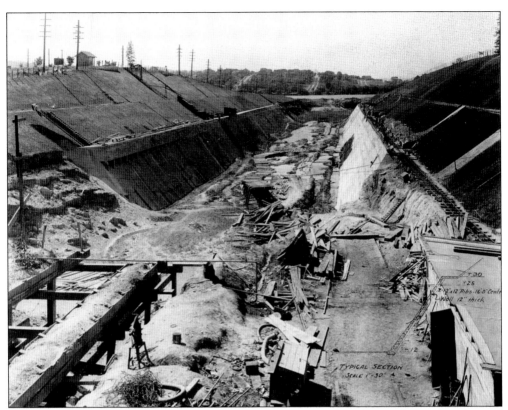

The work moved ahead quickly. By mid-1912, nearly a quarter of a million cubic yards of dirt and other material had been removed from the site. The work of pouring cement and shoring up the canal walls was also progressing rapidly.

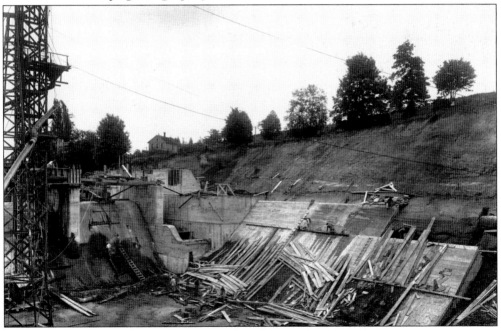

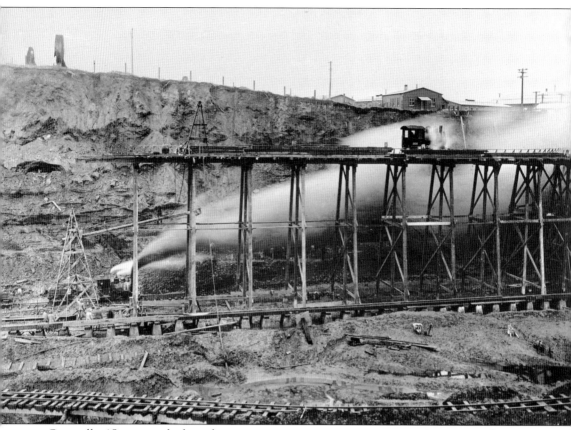

Generally, 15 men worked on three cement mixers at any given time. An estimated 200,000 cubic yards of cement were used in the construction of the locks. Some four million cubic yards of cement were used for the entire canal.

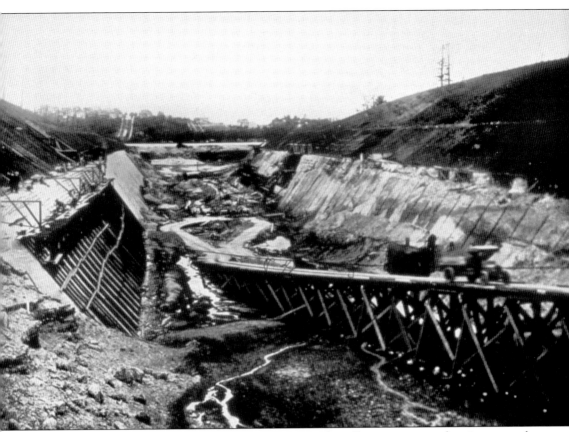

Temporary rail lines, roads, and scaffolding were erected to allow movement of equipment and materials. The first concrete for the locks' walls was poured in early 1913.

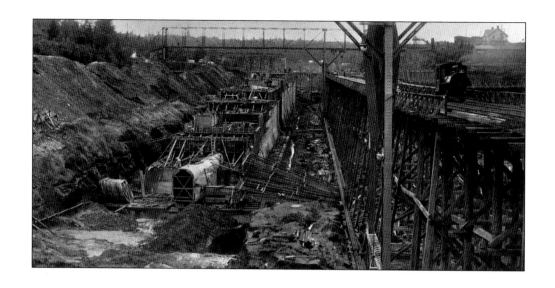

The walls were completed by the summer of 1914, except for some parts left out to allow for passage of construction trains on temporary elevated tracks.

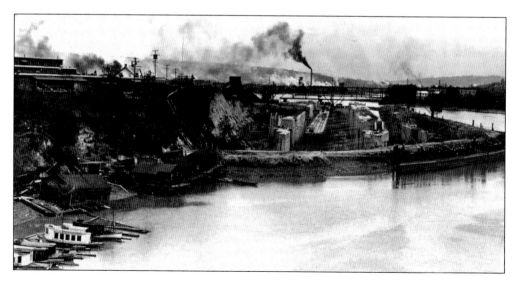

The construction of all of the major buildings, shops, and wharves for the locks was on schedule as well. These buildings included a large Administration Building, carpentry shop, metal shop, and others. (Below, courtesy Julie Albright.)

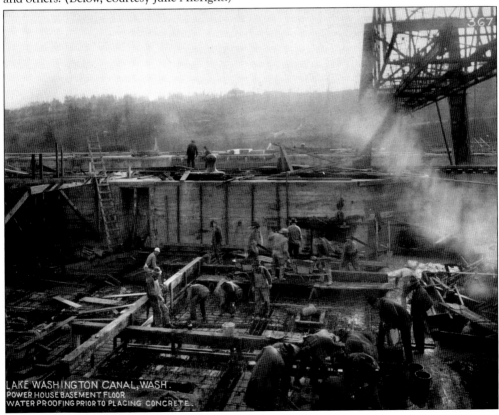

LAKE WASHINGTON CANAL, WASH.
POWER HOUSE BASEMENT FLOOR
WATER PROOFING PRIOR TO PLACING CONCRETE.

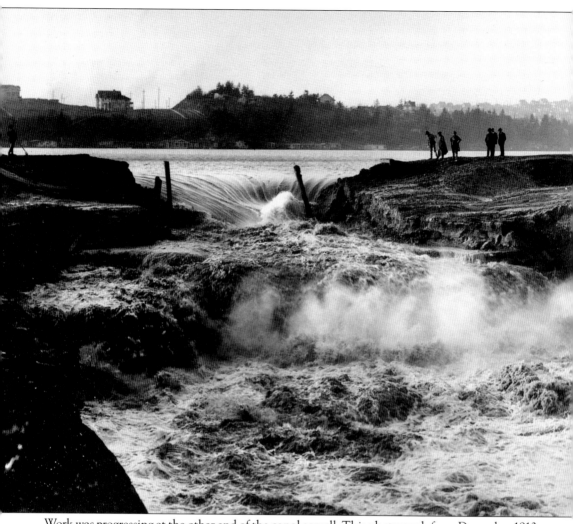

Work was progressing at the other end of the canal as well. This photograph from December 1913 shows workmen breaching the cofferdam (a temporary barrier meant to keep water away from an area that is normally submerged). The removal of this dam allowed Lake Union to connect with Lake Washington. (Courtesy Museum of History and Industry/Puget Sound Maritime Historical Society.)

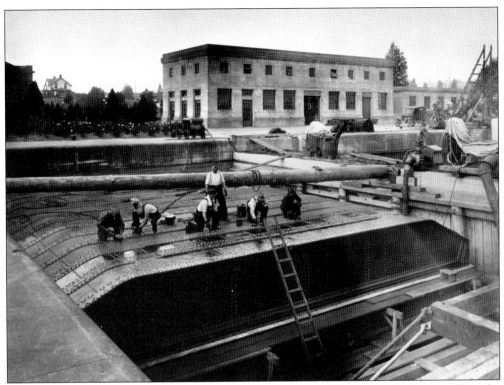

By mid-1914, the locks' floors and walls were complete except for portions left out to allow the passage of construction trains running on the temporary elevated tracks. The next major part of the project involved installing the steel gates.

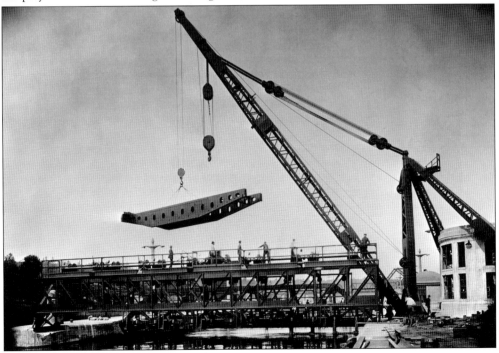

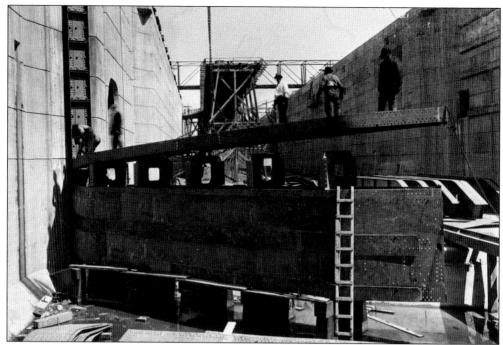

This task continued until the summer of 1915. By the summer of 1916, work was winding up on the Montlake Cut (as the portion of the Ship Canal from Salmon Bay to Lake Union was called). In July, the lock gates closed for the first time and the filling of Salmon Bay began.

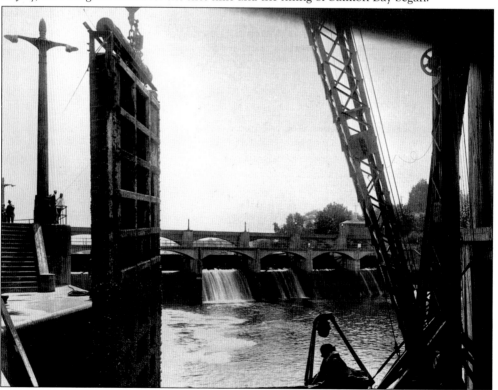

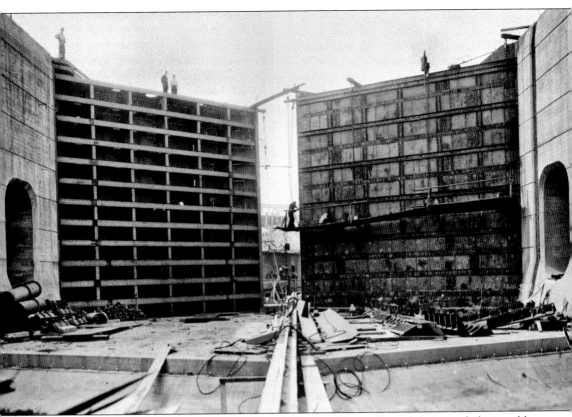

Laborers working on the locks were typically paid $2 a day. They collected their pay daily, in gold and silver, handed to them from a booth inside the Administration Building. The men working here give a sense of scale to what they are installing.

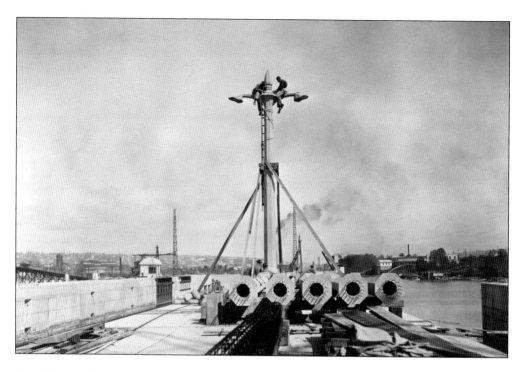

Installing an adequate lighting system was crucial (above), since it was important that the locks be usable 24 hours a day. Below, this and the other main support buildings for the locks, constructed in cement, were designed by Carl F. Gould and Charles H. Bebb, prominent members of the Seattle architectural community at the time.

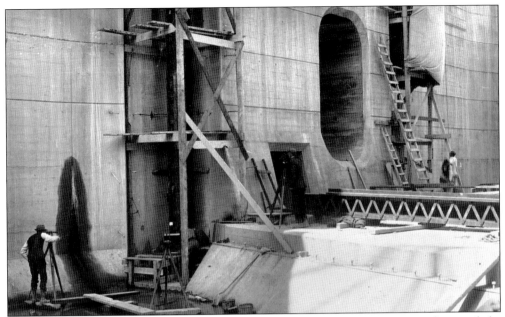

The locks complex, at this point, was not completely finished. However, it was ready enough for an impatient public, eager to see the first traffic pass through. After years of wrangling and hard work, the enormous project was finally usable.

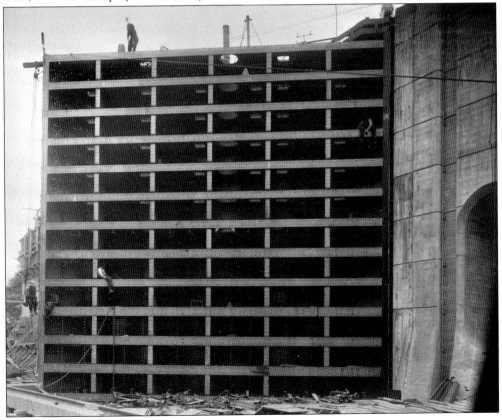

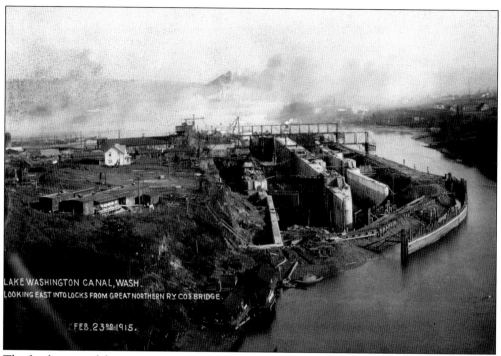

LAKE WASHINGTON CANAL, WASH.
LOOKING EAST INTO LOCKS FROM GREAT NORTHERN RY CO'S BRIDGE.

FEB. 23RD 1915.

The final pieces of the project were falling into place. The eastern gates were removed, and with the filling of Salmon Bay, a navigable channel was complete. The process of filling the bay lowered Lake Washington by about 9 feet, from a mean elevation of about 30 feet to 21. Meanwhile, the "new" Salmon Bay, above the locks, was raised some 21 feet to match the level of Lake Union. (Both courtesy Julie Albright.)

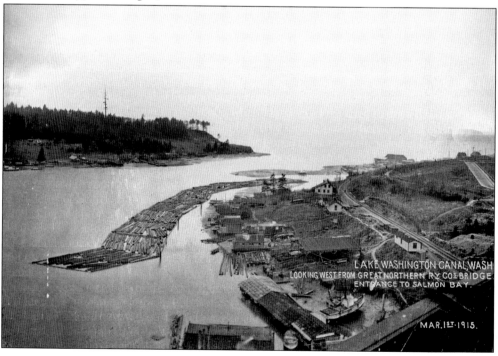

LAKE WASHINGTON CANAL WASH
LOOKING WEST FROM GREAT NORTHERN RY CO'S BRIDGE
ENTRANCE TO SALMON BAY.

MAR. 1ST 1915.

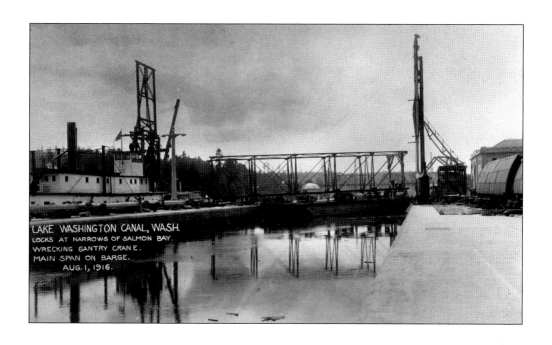

LAKE WASHINGTON CANAL, WASH.
LOCKS AT NARROWS OF SALMON BAY.
WRECKING GANTRY CRANE.
MAIN SPAN ON BARGE.
AUG. 1, 1916.

In August 1916, the final obstacles to using the locks were out of the way. At this time, the facility was referred to simply as "The Government Locks" or "The Ballard Locks." It would continue to be known by those names for many years.

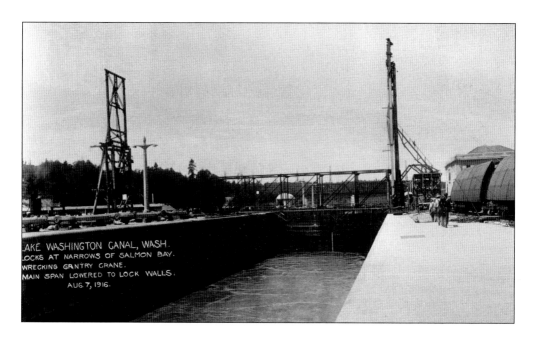

LAKE WASHINGTON CANAL, WASH.
LOCKS AT NARROWS OF SALMON BAY.
WRECKING GANTRY CRANE.
MAIN SPAN LOWERED TO LOCK WALLS.
AUG. 7, 1916.

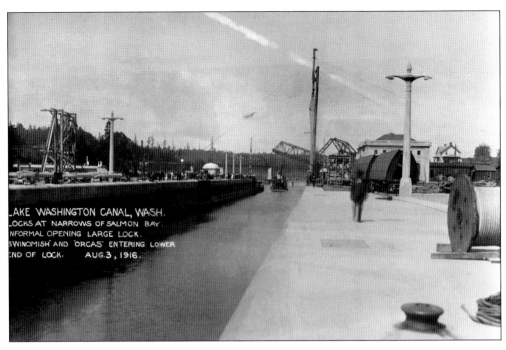

LAKE WASHINGTON CANAL, WASH.
LOCKS AT NARROWS OF SALMON BAY.
INFORMAL OPENING LARGE LOCK.
SWINOMISH AND 'ORCAS' ENTERING LOWER
END OF LOCK. AUG.3 , 1916.

The first vessels through the locks were the Corps of Engineers' launch *Orcas* and snag boat *Swinomish*. Reports indicate that about 2,500 people assembled along the banks of the facility to watch them transit through in the summer of 1916 (though crowds are not apparent in these photographs). The facility was put to immediate and frequent use. Between August 1916 and its formal dedication ceremonies the following summer, some 17,000 vessels would pass through the locks.

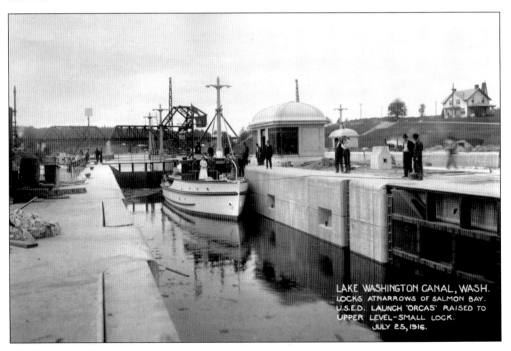

LAKE WASHINGTON CANAL, WASH.
LOCKS AT NARROWS OF SALMON BAY.
U.S.E.D. LAUNCH 'ORCAS' RAISED TO
UPPER LEVEL–SMALL LOCK.
JULY 25, 1916.

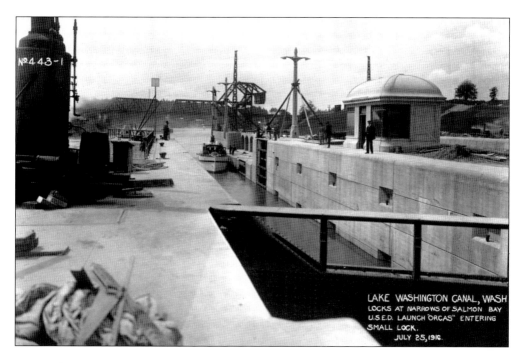

LAKE WASHINGTON CANAL, WASH
LOCKS AT NARROWS OF SALMON BAY
U.S.E.D. LAUNCH "ORCAS" ENTERING
SMALL LOCK.
JULY 25, 1916.

During the fall, winter, and spring of 1916–1917, as the last touches were put on the facility and the rest of the Ship Canal, the locks remained informally open for business. By May 1917, the entire canal and locks complex was completed and navigable. In all, the project had taken some five and a half years, at a cost of about $5 million (roughly $84 million in today's money, adjusted for inflation).

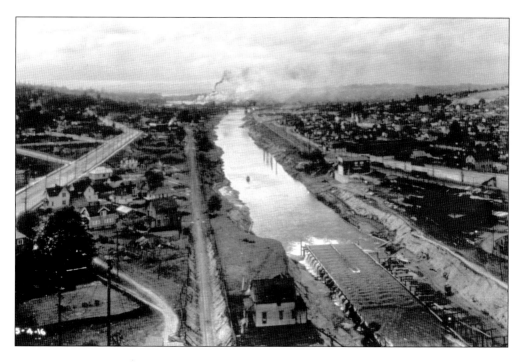

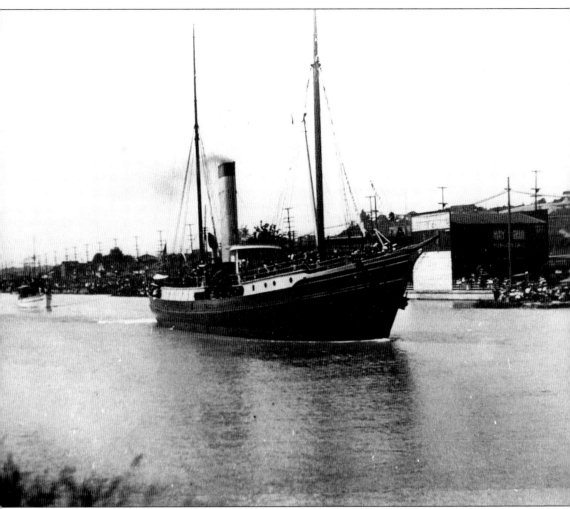

On July 4, 1917, the locks were formally opened with a grand celebration. Officials read a congratulatory telegram from Theodore Roosevelt. The former president was, of course, a famous canal builder himself—he had been instrumental in seeing through the construction of the Panama Canal. Fittingly, the day's "guest of honor" was the *Roosevelt*, pictured here.

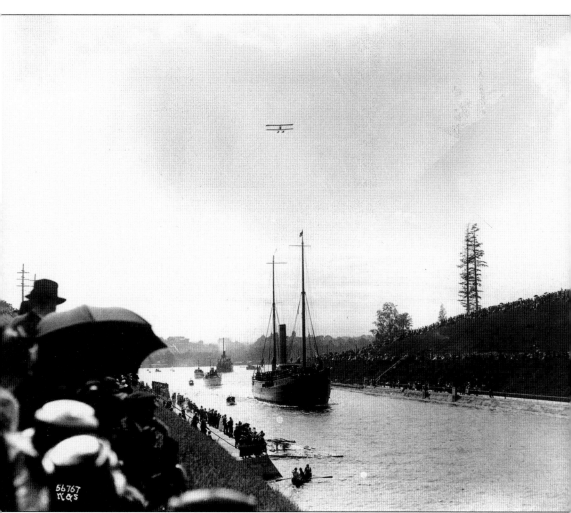

Teddy Roosevelt's telegram read as follows: "Oyster Bay, NY July 3, 1917; To: Daniel Landon, Chairman, Canal Program Committee, Seattle, Wash. I heartily congratulate Seattle and Washington on the completion of the canal. It is of great consequence commercially and may become of at least as great consequence from the Navy standpoint. The event you celebrate is of consequence to the whole country. Theodore Roosevelt." Many other events took place that day. Bands played, crowds cheered, speakers orated, and one of Bill Boeing's first biplanes flew overhead (just visible in this photograph). Many of the speakers that day stressed how the locks typified America's spirit of ingenuity, a spirit they assured the crowds was bound to triumph in the world war that was then raging in Europe and which America was just entering. (Courtesy Museum of History and Industry/Puget Sound Maritime Historical Society.)

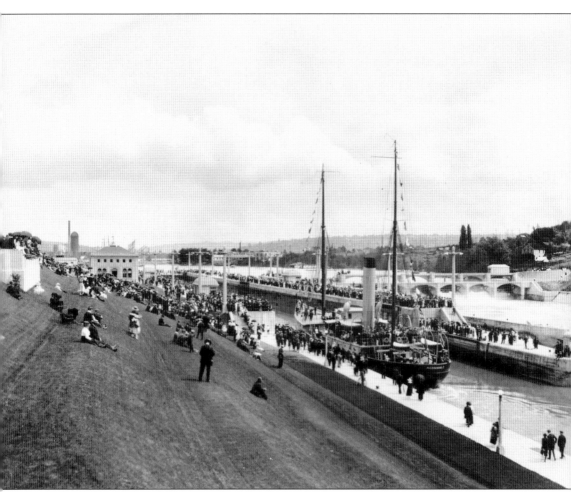

Following these speeches, several hundred vessels traveled through the new locks and on to Lake Washington. They were ceremonially led by Admiral Peary's polar flagship, the *Roosevelt*. This ship, renowned for having transported the explorer on his 1909 expedition to the North Pole, had by 1917 been converted into a motorized fisheries vessel. An anonymous reporter for the *Seattle Times* had this to say about the day's events: "Seattle's Lake Washington Canal is open for business. It opened today, conspicuously, ostentatiously. It played to capacity on its first performance—the principal feature of Seattle's Fourth of July celebration. Hundreds of government and commercial craft, citizens of Seattle and other Sound communities by the hundred thousand, speakers of renown, bands, parades, fireworks, athletic contests, flowers, prizes, dancing, barbecues, reminiscences and I-told-you-sos were there." (Courtesy Museum of History and Industry/Puget Sound Maritime Historical Society.)

Two

THE LOCKS IN ACTION

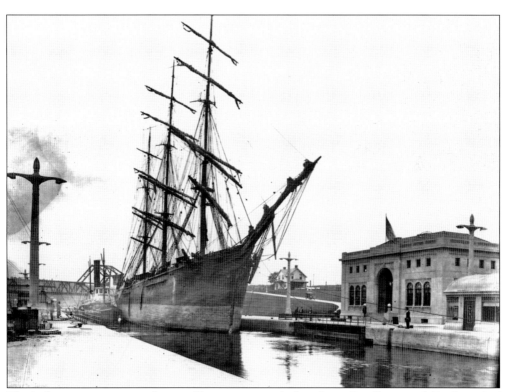

The locks were put to immediate and heavy use even before they officially opened. By the end of 1916, months before the grand opening, about 7,500 vessels had already passed through. These early-bird ships and boats transported some 12,000 passengers and 201,000 tons of freight worth nearly $2 million. Here the sailing vessel *Abner Coburn* enters the large lock in 1916. Notice how visible Cavanaugh House is in the background, before any trees have been planted.

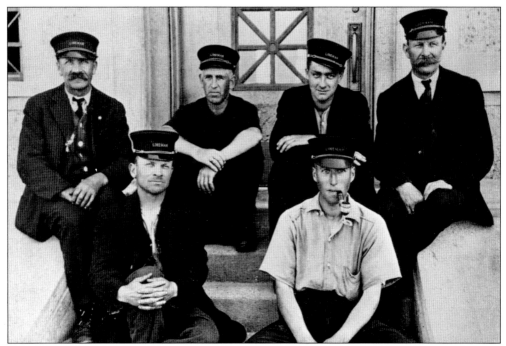

The pace increased in 1917, the first full year of operation. That year, the locks accommodated 22,392 tugs, fishing boats, pleasure craft, and other vessels. By now, the facility required a permanent staff of 49 employees, including lockmen, electricians, and machinists. The first locking crew poses in the 1917 photograph above. From left to right are (first row) Harrie Meecham and Ray Foster; (second row) August Falk, George Putnam, Alvin D. Wells, and Andrew Anderson. Below, in 1922, the freighter *Meighen Maru* is in the large lock, bound for Stimson Lumber to take on a shipment for Japan.

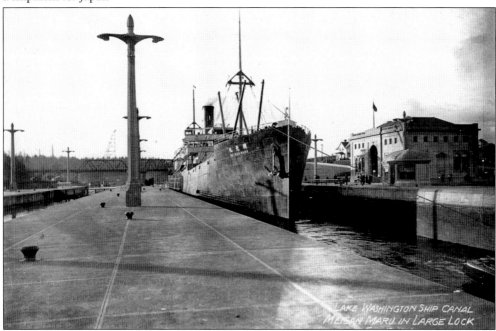

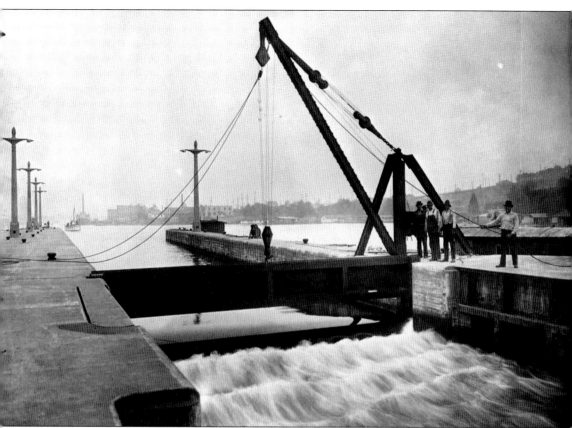

The locks had a dramatic effect on Seattle's waterways. Lowering Lake Washington left existing docks high and dry, and it eliminated the lake's natural outlet. But it also created extensive new waterfront. For example, Matthews Beach Park, on the northwest shore, was once completely underwater. (The present-day Burke-Gilman Trail, following a curving railroad link, indicates the edge of the original cove.) All told, Seattle now boasted roughly 130 miles of prime waterfront property. Lake Union developed primarily into a working lake, with marine businesses lining its shores. For a time, such activities also took place on Lake Washington, including shipyards in Kirkland and a whaleboat station on Meydenbauer Bay. Many regional boosters hoped Lake Washington would develop into an industrial region to rival those of the Midwest and Eastern Seaboard, but this never happened to any extent. Fortunately for the aesthetic pleasures of future generations, Lake Washington waterfront became mostly for homes and parks. Seattle's Eastside thus never became "The Pittsburgh of the West." Pictured here, the top gate or "log" of the original small lock emergency dam is set in place in August 1923. Note that there are no safety rails—and that the crane is hand-operated.

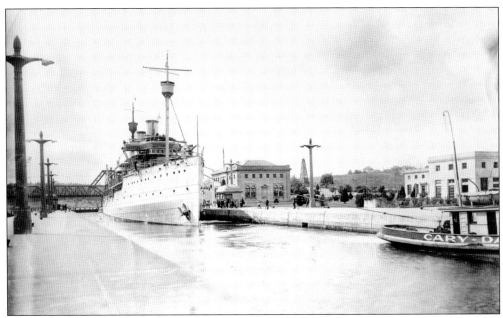

The navy did establish and maintain an air base at Sand Point on Lake Washington from 1920 to 1970 on the site of what is now Magnuson Park. The minelayer USS *Aroostook* is shown above en route through the locks, on her way to Sand Point Naval Air Station, in 1924. Built in 1907 as a coastal passenger steamer, the *Bunker Hill*, the *Aroostook* was acquired by the navy in 1917 and converted into a military vessel. Below is a U.S. Coast Guard scow in June 1936.

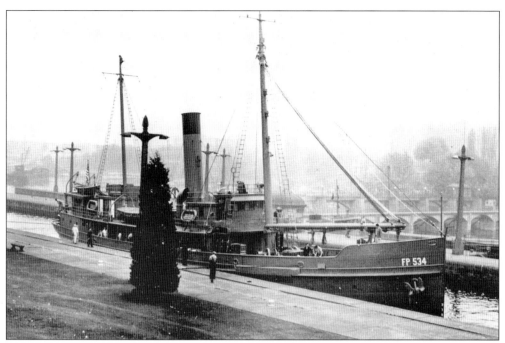

However, one outcome that did not come to pass for Lake Washington—ironically, considering the corps' original plan—was the creation of a major naval station there. In retrospect, it was fortunate that the new base was instead established across Puget Sound in Bremerton; some naval ships soon were so large that many of them would not have been able to pass through the locks. Above is the buoy tender *Heather* on January 27, 1945. Below is light station tender No. 334 on January 27, 1945.

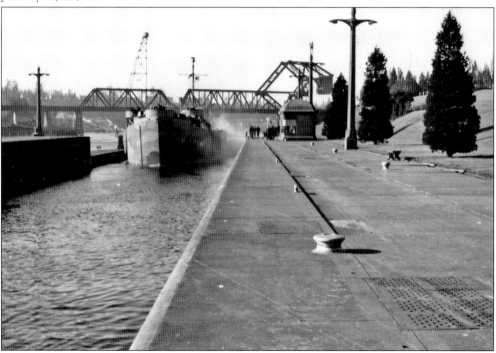

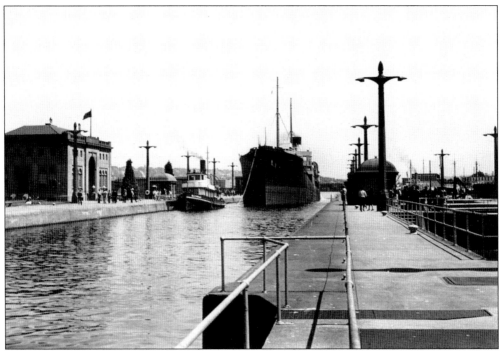

Commercial traffic through the locks continued to rise, and by 1923, it had hit $21.6 million worth of cargo for the year. This brisk activity put to rest any lingering doubts skeptics still had about the project's economic worth. The bulk of the economic activity at this point was lumber-related. Over half of the traffic through the locks consisted of logs, typically floated through the large lock as rafts.

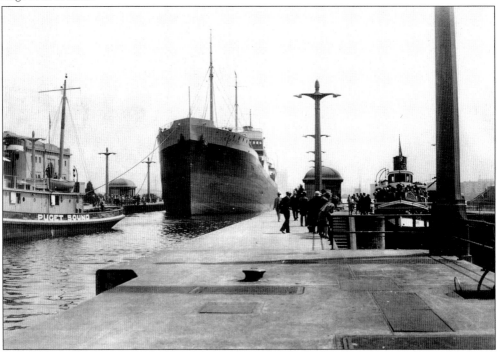

Widening and dredging the canal, or building a third lock, was a possibility as traffic increased. However, by the mid-1920s, the nature of this traffic was changing; alterations no longer seemed necessary. One change concerned the kinds of vessels coming through. Seattle's population was growing; tugboat traffic was declining, but the numbers of other kinds of boats coming through the locks tripled between 1925 and 1950. Many were pleasure boats as Seattle grew and its residents discovered the joys of boating.

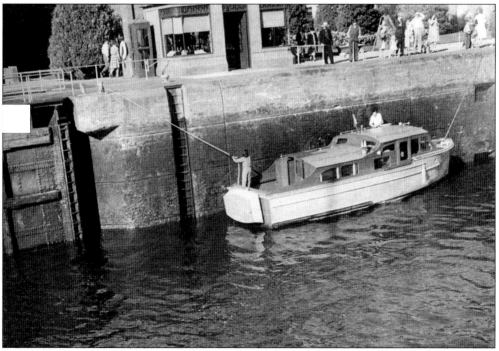

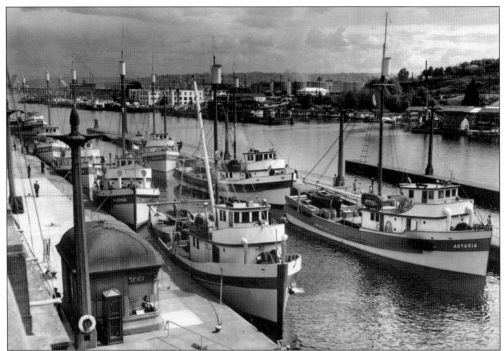

Commercial fishing boats also accounted for much of the new traffic. This fleet was primarily based at Fisherman's Terminal. Construction of the terminal took place during 1913–1914 in Salmon Bay as the locks were being built. It was expanded several times over the following decades, with added and improved moorage, dry docks, and facilities for repair, maintenance, and supply. Today Fisherman's Terminal covers some 76 acres and is still home to more than 700 working boats. Meanwhile, the corps continues to conduct studies to make sure the locks remain adequate.

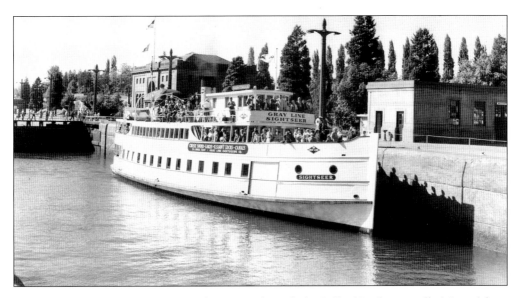

It is estimated that today some 75,000 boats pass through the Ballard Locks annually. Most of these are private vessels, sailboats as well as "stinkpots." Nonetheless, a great deal of commercial cargo still passes through the locks as well—over two million tons of it every year. Roughly half of the commercial cargo today is sand and gravel; about 22 percent is forest products; 8 percent petroleum products; 1 percent fish; and 19 percent other (clothing, food, and so on, usually in containers). Above is the tourist boat *Sightseer* in August 1956. Below is a tug with a log raft in 1956.

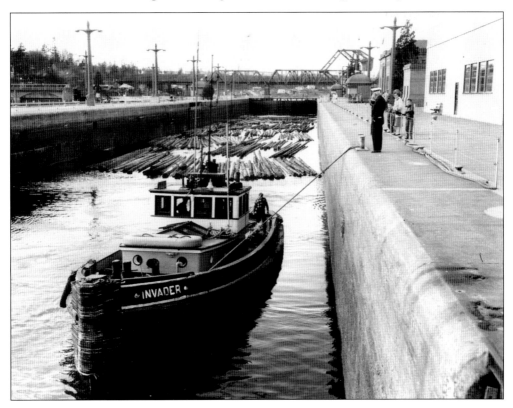

It is this function of the locks—the movement of vessels—that is of the most enduring interest to the public. Boats and ships of all sizes and types "lock through" all day and night and seven days a week. About eight million gallons of water are used every time the large lock is put into action, while only about half a million are used with the small lock. A tug is going through the locks above in June 1947. Below is the submarine *Tilefish*, shown in March 1947.

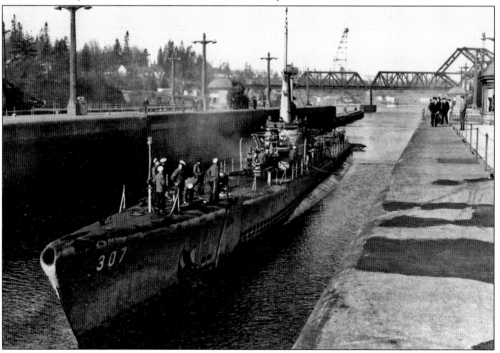

At any given moment, visitors might see anything from sailboats, canoes, kayaks, and yachts to research ships, sightseeing vessels, tugs, fuel and gravel barges, and fishing boats go through. The 18-foot survey boat above was built by locks personnel in 1945. Below, the fleet oiler *Tolovana* is towed through the locks in July 1947.

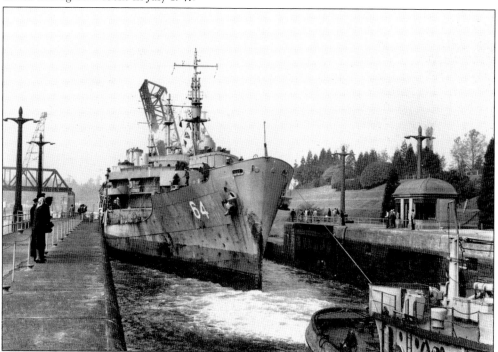

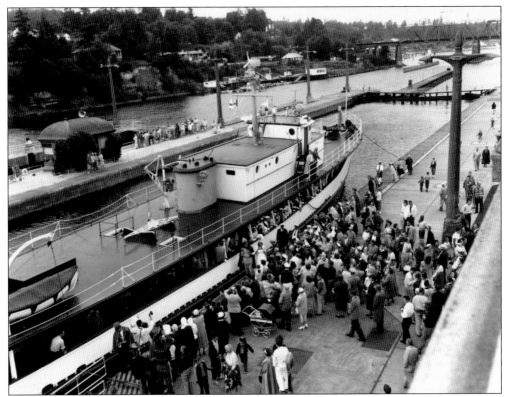

A longtime Seattle summertime tradition is its annual Seafair celebration, which over the years has included hydroplane racing, mock-fierce "pirates," parades, and more. In the above photograph from July 1955, civic leader George Kachlein Jr.—crowned that year's "King Neptune, Emperor of the Ocean and King Of All the Seas"—arrives with his entourage at the locks. Below is the fishing boat *Majestic* in August 1956.

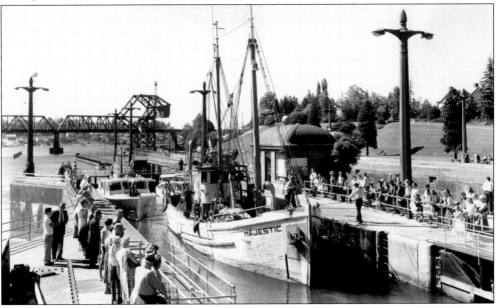

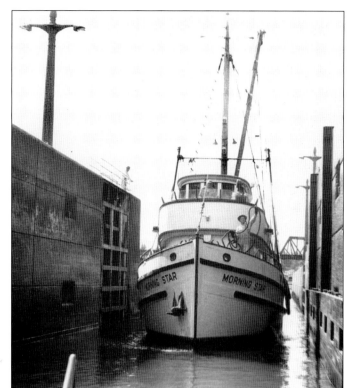

The *Morning Star* (right) was part of Seattle's growing fleet of commercial fishing boats in May 1957. A replica of the HMS *Bounty*—built in 1960 for the Marlon Brando film *Mutiny on the Bounty*—visits Seattle as part of the Century 21 World's Fair celebrations (below) in June 1962.

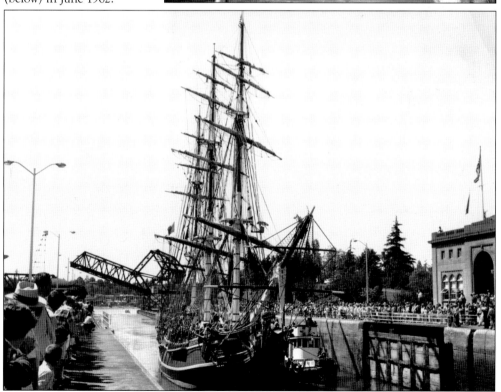

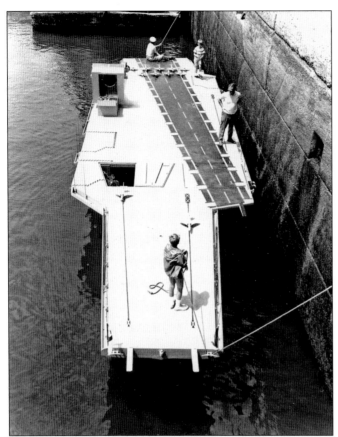

Pictured left is a model aircraft carrier in July 1967. Launched in 1944 (and pictured below in 1968), the submarine *Razorback* was decommissioned twice (in 1952 and 1970), then sold to the Turkish navy, where she served as the *Murat Reis* until 2002. In 2004, the *Razorback* was sold to the Arkansas Inland Maritime Museum.

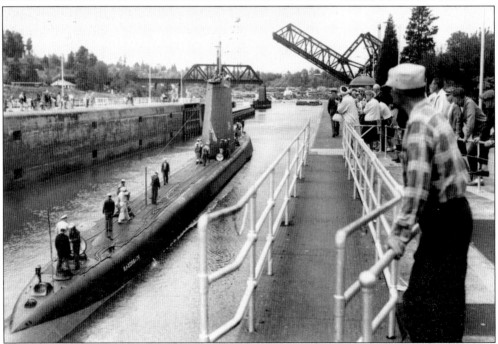

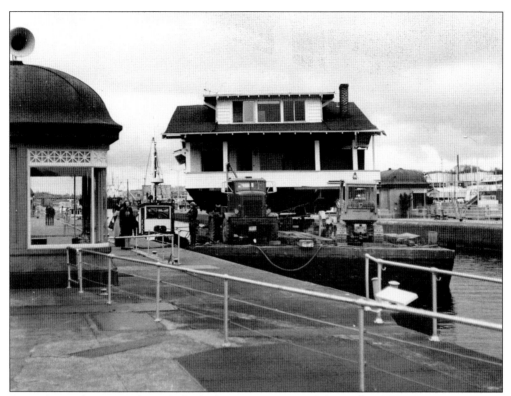

Some things that move through the locks are more unusual than others. This house was locked through on a barge in November 1977. The floatplane, meanwhile, was towed through the locks by hand.

The locking through of an enormous floating dry dock (above) took a year to plan. It was tipped on its side with ballast to squeeze it through. "Amphicars," amphibious cars, are capable of being driven on land or piloted on water. They were made in Germany in the 1960s. Here is one (left), in a 1962 photograph, coming through the locks.

A damaged B-29 bomber is pulled through the locks above. Below, the waste burner from a dismantled lumber mill is towed out. The bomber photograph is dated September 22, 1944, and the second photograph was probably taken in the late 1930s or early 1940s.

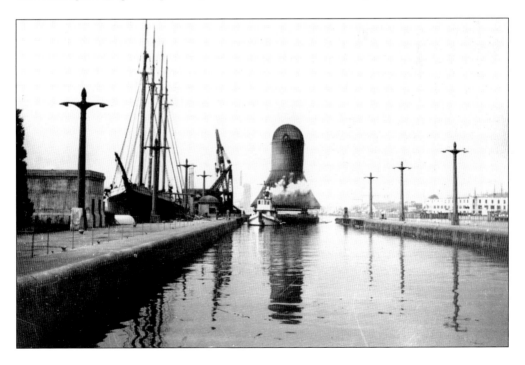

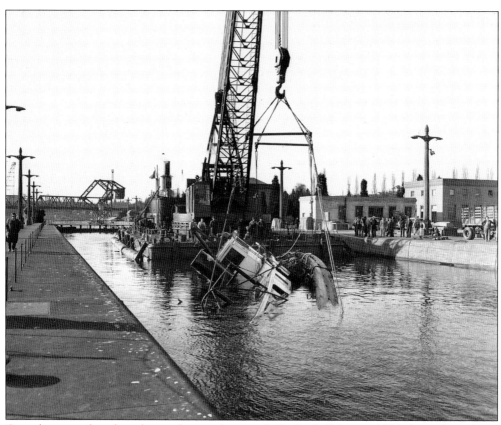

Over the years, there have been a few accidents at the locks. In February 1944, the tugboat *Annie* (above) sank in the large lock but was successfully brought back up to the surface. The *Aleutian Lady* got stuck sideways in the large lock in 1968 (below). She was eventually pulled free by an Army Corps of Engineers workboat.

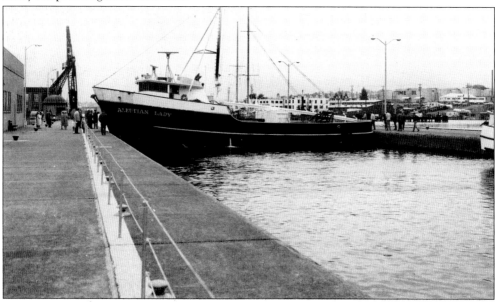

The Corps of Engineers has made many modifications to the locks over the years. In fact, the corps officially considered its massive canal-lock project only three-quarters complete when it was dedicated in 1917. Some of these changes were temporary. For example, during the summer of 1943, wartime barracks for a Coast Guard unit were built on the site. The barracks are under construction above and closer to completion below.

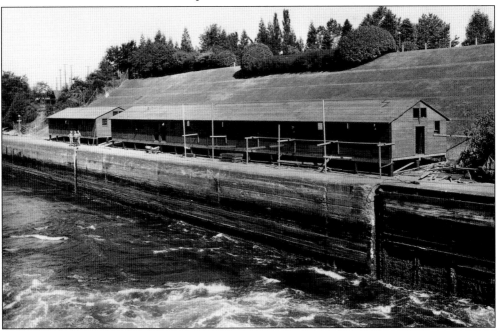

This arm is a safety device that has never been used—and with luck it never will. In the event of a failure of the lock gates, the arm would lower a set of "logs" (seen in the background), one on top each other, into slots on either side of the lock, forming an emergency dam that would hold the water back. Compare this arm with an earlier version of the same basic kind of safety device on page 57. There have been many other modifications over the years. For example, the cable system originally used to operate the miter gates proved unsatisfactory. Saltwater quickly deteriorated its steel cables, and it required constant maintenance by divers. The cable system was therefore replaced in 1934 with a crank-gate gear system. This system was exceptionally durable. The gear drives manufactured for it in Philadelphia had an expected lifespan of 50 years but proved usable for several years beyond that. This system has since been replaced by hydraulics. (Courtesy Leah Woog.)

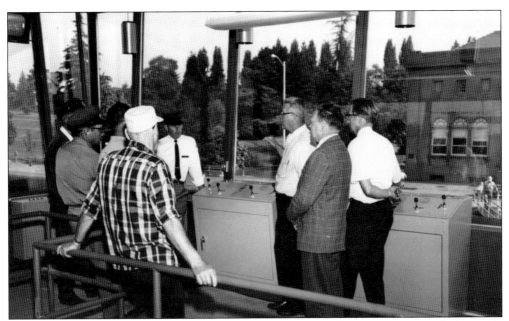

Another example of improved performance is a centralized control system installed in 1969 to combine the functions of four small control buildings into one. The main control tower, on the middle lock wall, is the lockmaster's station. Typically, four people hold down the position of lockmaster at a time, so three shifts of personnel can provide 24-hour coverage with backup. Although both locks can be operated from the main control tower, locks personnel generally operate the small lock from a separate control house. Security concerns limit the taking of photographs in certain areas of the locks these days. The June 1969 photograph above shows personnel being briefed on new equipment in the northwest control tower. Below is a view of the central control tower today. (Courtesy Leah Woog.)

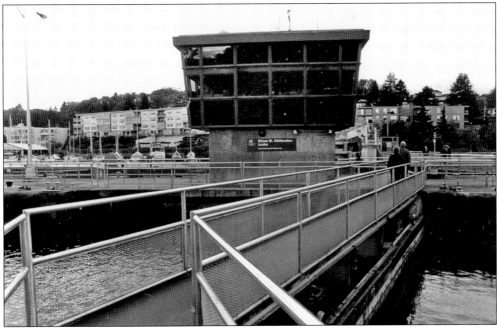

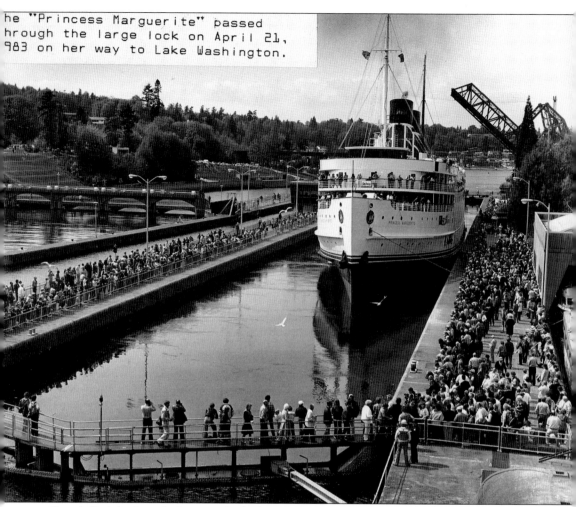

he "Princess Marguerite" passed
hrough the large lock on April 21,
983 on her way to Lake Washington.

Crowds line the large lock to watch the liner M/V *Princess Marguerite II* as she makes her way through the large lock, bound for Lake Washington, on April 21, 1983. This was the second of three small luxury liners by that name. She was a well-loved and familiar sight around Seattle for years, traveling the "triangle route" between there and Vancouver and Victoria, Canada, from 1949 until 1979. After a major overhaul, she was returned to service from 1981 to 1989. The *Princess Marguerite II* then spent time as a floating gambling casino in Southeast Asia and was finally scrapped in 1997. The ship had been preceded by the first *Princess Marguerite*, which was converted to be a troop transport during the Second World War and was torpedoed by a German submarine in the Mediterranean with 60 lives lost. Third in line was the M/V *Princess Marguerite III* (formerly the *Queen of Burnaby*), currently still in service as a ferry in British Columbia under her original name.

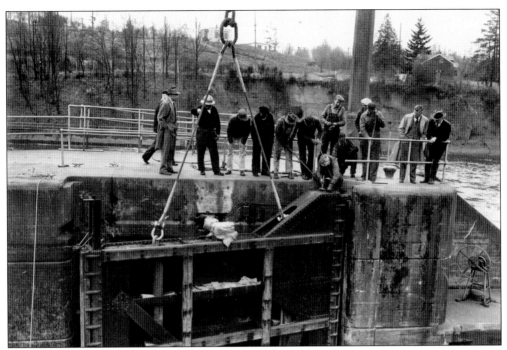

As with any such large facility, a regular part of life at the locks involves routine maintenance on parts both large and small. For example, each lock is closed yearly so it can be drained and thoroughly cleaned. (Lock personnel report finding many sunglasses, cell phones, and other items dropped by boaters.) Here personnel perform maintenance on the gates of the small lock, probably in the 1940s. Note how relatively undeveloped the shoreline is in the first photograph.

Another task involves replacing broken gearboxes, such as this one (above) on the northeast gate of the small lock in April 1968. In the photograph below, one of the 250-ton leaves on a miter gate is in dry dock, later floated down the canal and placed in position. This work was part of a major rehabilitation and repair project in the fall and winter of 1971—the first major such work on the gate since its construction in 1916.

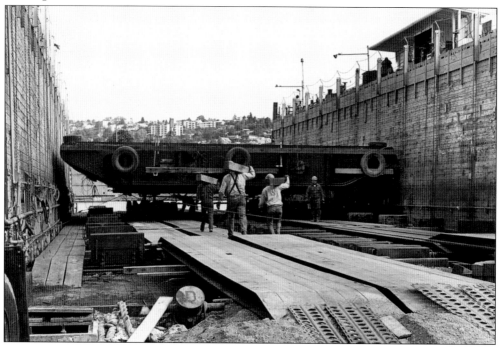

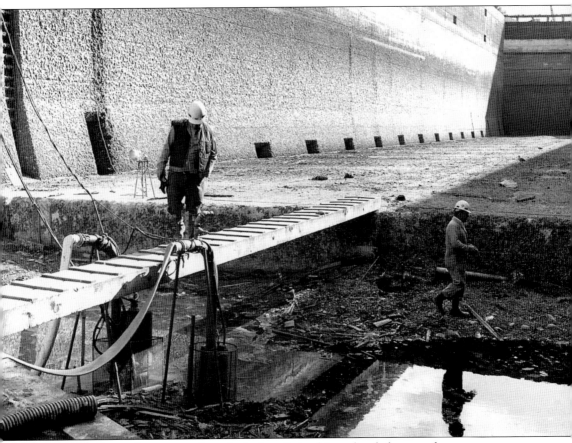

Note all the barnacles encrusted on the lock walls in this undated photograph.

Running the locks takes a large, dedicated, and knowledgeable staff. The current roster encompasses about 50 full-time federal employees plus janitors and visitor center staff. In addition, representatives of the Muckleshoot Indian Nation and the state Fish and Wildlife Department are on hand as fish counters and sea lion monitors. Above, Susan Connole, a visitor center staff member, takes the public on a tour. The central control tower is in the background. Below, Ed Hornsby, a welder, was photographed in 1978. (Above photograph by Adam Woog.)

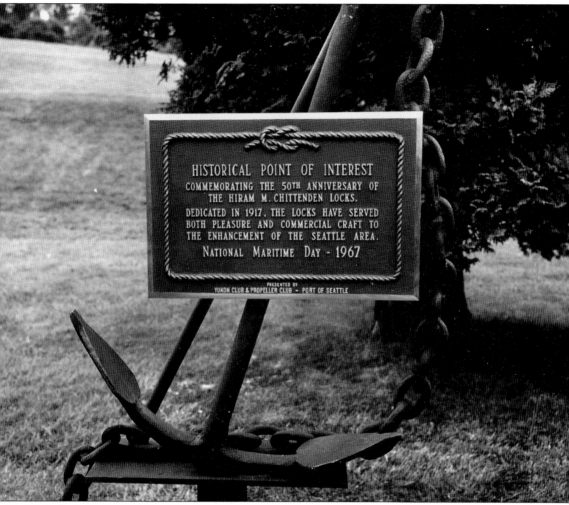

HISTORICAL POINT OF INTEREST
COMMEMORATING THE 50TH ANNIVERSARY OF
THE HIRAM M. CHITTENDEN LOCKS.
DEDICATED IN 1917, THE LOCKS HAVE SERVED
BOTH PLEASURE AND COMMERCIAL CRAFT TO
THE ENHANCEMENT OF THE SEATTLE AREA.
NATIONAL MARITIME DAY - 1967

PRESENTED BY
YUKON CLUB & PROPELLER CLUB - PORT OF SEATTLE

Over the years, a number of important historical milestones have passed at the locks. For example, in July 1956, Congress formally authorized that the facility be named in honor of Hiram Chittenden. In 1967, a memorial was placed to commemorate the locks' 50th birthday. That year, a number of other events also celebrated the facility's birthday. Flags flew along the walls as they had in 1917, a bronze plaque was placed at Cavanaugh House, and the Magnolia Community Club placed a plaque on the Administration Building. The memorial pictured here was donated by the Yukon Club and Propeller Club, Port of Seattle Chapter. During the formal ceremony marking the anniversary, a replica of an old Boeing airplane performed a flyover and a flotilla of workboats paraded through the locks, re-creating as closely as possible the 1917 grand opening. U.S. senator Henry M. Jackson was the featured speaker, and members of the Chittenden family were among the honored guests.

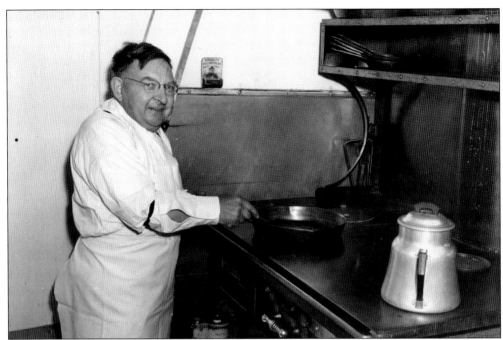

Above is Fritz Ryberg, cook on the Corps of Engineers' snag boat *W. T. Preston*, probably in the early 1950s. Stationed at the locks and named in honor of the only civilian engineer to work for the Corps of Engineers when she was built in 1929, the 163-foot *Preston* (shown below in 1975) was the last stern-wheeler to work in Puget Sound. Her main job was to remove snags and other navigational hazards from Puget Sound and its tributaries, although the *Preston* was often sent further afield. Over the years, she also performed light dredging, firefighting, and other work. She even retrieved a sunken military bomber and several automobiles. The *Preston* remained in service until 1981 and is now in dry berth on the waterfront in Anacortes, Washington.

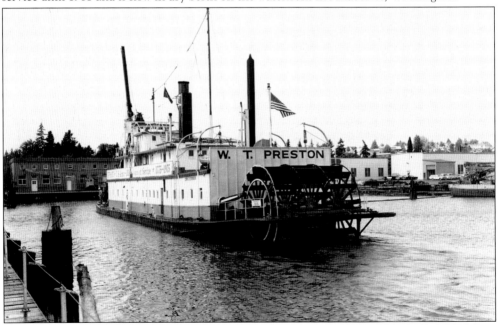

Orchestrating a "locking through," as a passage through the locks is called, is a complex job—a little like assembling a giant puzzle. One hundred boats or more might be in the locks at a time on a busy summer's day. To make sure it goes smoothly, personnel must consider such factors as the size of vessels, the experience of their crews, cleat locations and accessibility, and the total number of boats. Above is Charles Edmonson in 1978. That same year (below), Saunders Smith is in the foreground and Charles Edmonson in the background.

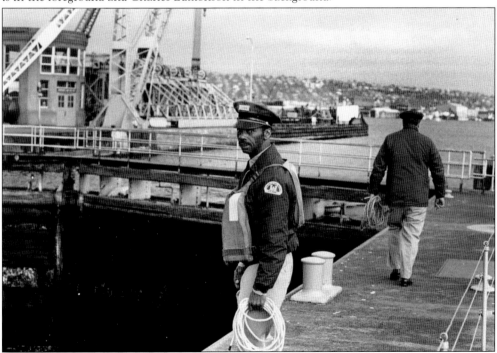

Nonetheless, the basic process of locking through is fairly straightforward. Westbound vessels—that is, those coming from freshwater into Puget Sound—enter one of the locks through the open upper gates on the east end of the locks. (If possible, for ease and economy, the small lock is preferred.) (Above, courtesy Leah Woog; below, photograph by Adam Woog.)

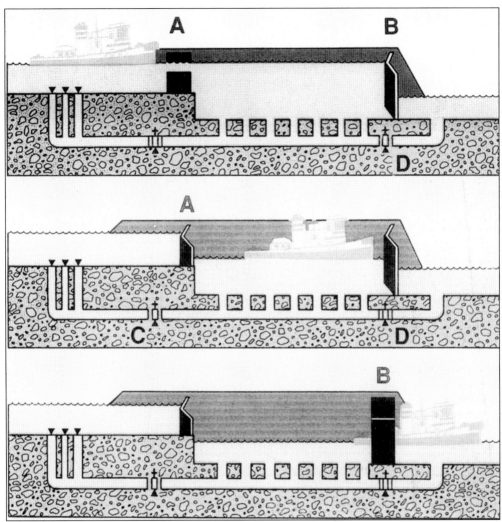

Once enough vessels have entered, lockwall attendants ensure that they are ready for the chamber to be lowered. The lower gates and draining valves (on the west end) are then closed. Next the upper gates and valves are closed and the draining valves on the west end are opened. Gravity drains the water in the lock into Puget Sound, and boats in the lock slowly "sink" to the new level. Miter gates, placed at angles to each other and pointed upstream, make sure the pressure of the flowing water seals the gates tight. When the water pressure and level are equal, the lower gates are opened. Vessels can then untie and leave the lock. For an eastward voyage, the process is simply reversed.

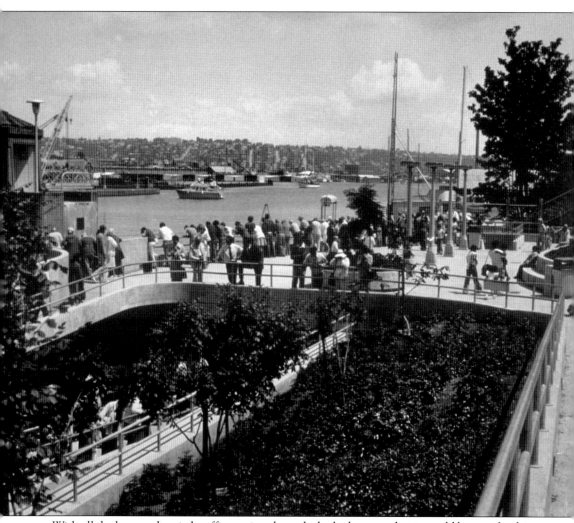

With all the busy and varied traffic passing through the locks every day, it would be easy for things to become chaotic or even dangerous. However, a well-defined set of procedures keeps things running smoothly. First come regulations about what equipment is needed to lock through. As a minimum, boaters need the following: Two sturdy mooring lines, at least 50 feet each, for the bow and stern, with eyes at least one foot in diameter (in the small lock, 15- or 20-foot lines are sufficient, but boaters should be prepared for the large lock); fire extinguishing equipment of the type and quantity prescribed by the U.S. Coast Guard; at least one Coast Guard–approved life vest (personal flotation device) for each person on board, which children and non-swimmers should wear at all times; and fenders for both sides because vessels may need to moor on either side of the lock chamber or to another vessel. Vessels should also be in good mechanical condition to minimize hazards to vessels, passengers, and spectators alike.

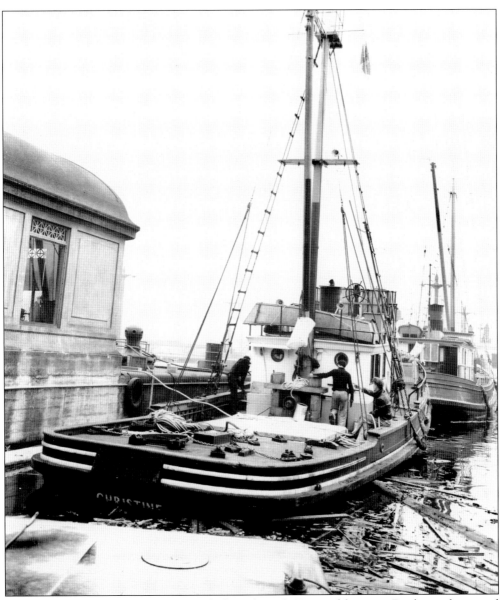

A set of basic rules helps ensure efficient locking through. First and foremost: Be alert and prepared for the unexpected. Also important are the following rules. When several vessels are waiting to lock through, the priority order is government and commercial vessels first, then pleasure craft. Larger vessels, because they are less maneuverable, have to right to enter the chamber before smaller ones. In most cases, waiting boats must stay on the south side of the channel and avoid the large lock. If waiting on the downstream side, they should stay between the small lock waiting pier and the public steps along the shoreline at Commodore Park. If waiting on the upstream side, they should stay east of the southern finger pier, between it and Lockhaven Marina. Knowing all the rules will help boaters learn the ropes of the locks. To get more specifics, boaters are urged to visit the facility before bringing a vessel through. Better yet, they can attend one of the locking-through classes the corps regularly sponsors.

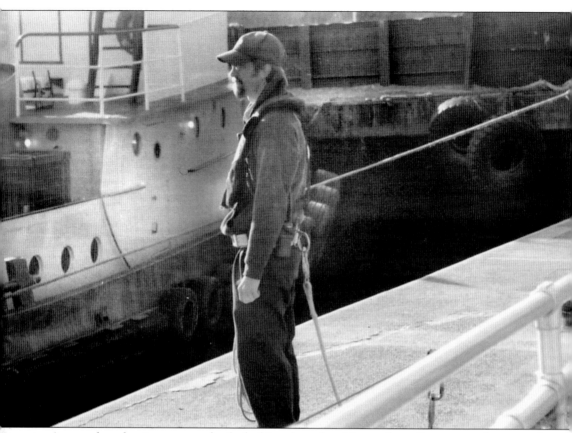

Among the other important rules for locking through safely are these. Boats must always avoid the spillway gates. The strong currents and eddies around them can be dangerous. Boaters will be notified when it is safe to enter the lock. Traffic lights for the small lock are located on the middle wall when westbound and at the waiting pier near the railroad bridge when eastbound. Besides watching these lights, boaters need to listen or watch for additional instructions from lock personnel. Lock operators will provide specific instructions about entering and mooring. It is good to acknowledge these instructions verbally or with a hand signal so the operators know they are being clearly understood. Boats must come into the lock slowly, at less than two and a half knots, with no wake. (The speed limit in the large lock is three knots.) They must always be under power. A drifting vessel does not have adequate steering control. (Courtesy Leah Woog.)

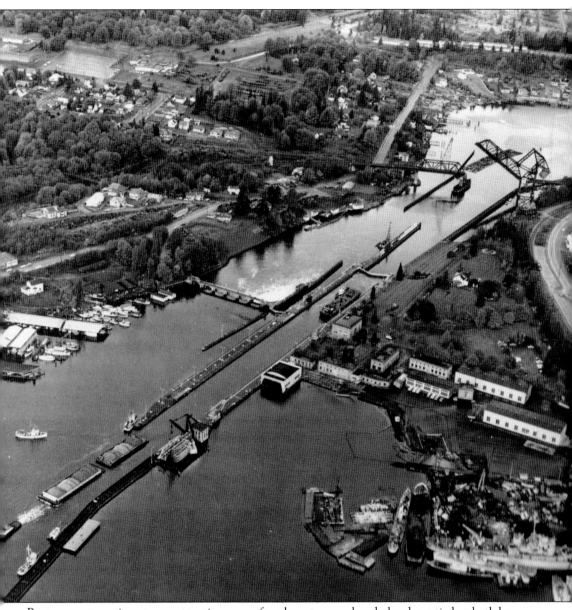

Boaters must continue to pay attention even after the gates are closed, they have tied up both bow and stern, and the lockage has begun. There are many reasons for this. For example, the crew of a boat in the small lock needs to be ready to pay out or take up lines if that lock's floating guide walls hang up. In such a case, boaters must immediately slacken their lines and notify an operator so the flow of water can be stopped. Failure to handle this properly can result in a vessel tipping or even sinking. Currents in the locks can be strong—as much as six knots—so lines must have no slack. These currents can happen because saltwater is denser than freshwater. This means that the pressure may be the same on either side of the gate, but the height of the water may differ by as much as a few inches. This difference can cause currents. Even after the water levels have changed, boaters must remain tied up while the gates are opened. They must await word to release their lines and move ahead slowly when it is safe.

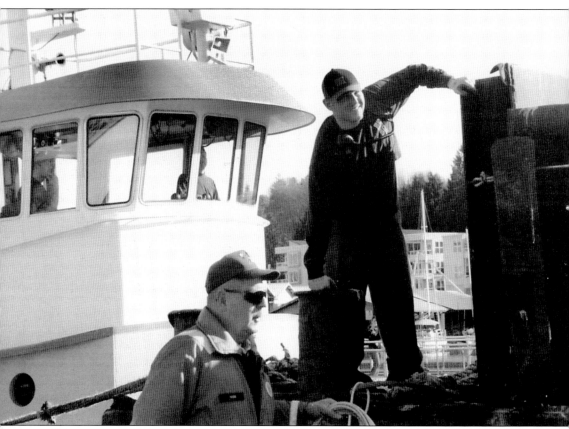

When casting off, the saltwater line—that is, the line on the western end of the boat—must come off first. This will be the bowline when heading into Puget Sound, the stern line when heading into the Ship Canal. This rule is important because of the direction of the current flow in the locks. Casting off in the wrong order can send a boat spinning down the lock chamber, crashing into other vessels. Boaters must not call the locks on channel 13. FCC restrictions prohibit corps staff from responding to noncommercial vessels on this channel unless it is an emergency. If a vessel draws more than 14 feet, the lockmaster needs to be informed of this ahead of time. This is because the lockmaster will need to lower the saltwater barrier. The signal for this event is one long and two short blasts. (Courtesy Leah Woog.)

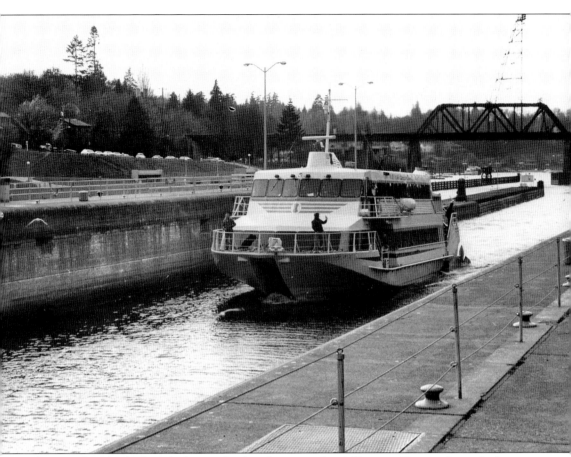

The procedure for the large lock is similar, but there are a few differences. For one thing, the large lock does not have floating mooring bits. Crewmembers must tend lines, paying out or taking up without slack. If the distance is too great to pass a line, the attendant will throw one. A slipknot secures the mooring line to the attendant's line and allows the attendant to pull the boat's line up. The attendant then secures the line to a mooring button on the lock wall. A half figure-eight knot holds the boater's end of the line so it can be paid out or taken up with no slack. Boaters must be especially vigilant to make sure their lines do not get hung up. The flow of water can be quickly stopped in the small lock, but it takes several minutes in the large lock. In that time, the water level can drop four or five feet and pull a boat's cleats out of its deck—or even leave the boat hanging high and dry. This photograph shows the Boeing-built jetfoil *Mikado* on November 1978, one of nearly two dozen jetfoils the company built for use around the world.

Boaters, don't do this at home—or anywhere else. Here are a few bad examples of improper locking-through technique that might be instructive. Pictured left, the line is being held in the inattentive attendant's hand, so he has little control. The line is too slack and could easily get fouled. Also, the line passes through the chock, but no turn has been taken around the bit. The line below is far too slack.

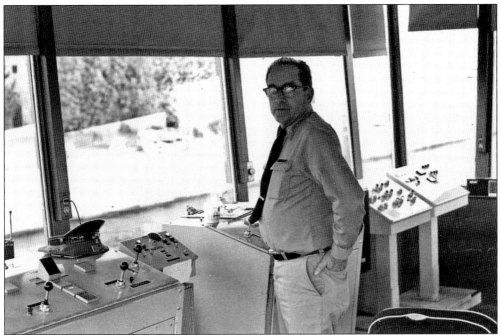

The lockmaster operates the large lock and oversees vessel traffic in general. He also controls freshwater levels by releasing water through the spillway dam as needed. Typically these levels vary only about two feet annually. Another of the lockmaster's responsibilities is the control of saltwater intrusion—that is, keeping saltwater and freshwater separate. High salinity (salt) levels could severely damage the region's freshwater ecosystem. Above is lockmaster Pat Quinn in 1978. Below are the *San Juan* and the *Orcas* moored side by side.

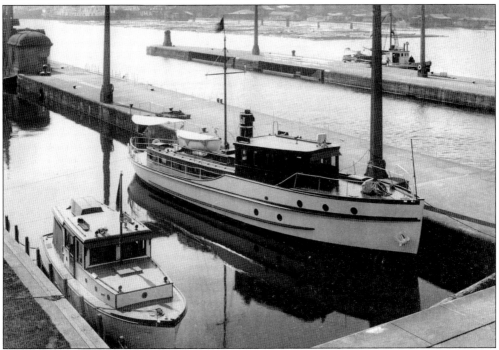

A number of factors can affect the degree of saltwater intrusion at any given moment, including tides, rainfall levels, and regular seasonal changes (such as summertime increases in boat traffic). Controlling saltwater intrusion depends on saltwater being denser and heavier than freshwater. When the locks are opened, saltwater settles into a basin that has been dredged out just above the large lock. The saltwater then drains to the downstream side of the spillway dam and returns to Shilshole Bay. The outlet of this system's drainage pipe is visible at the dam near the small lock. Above are the *St. Paul*, *Swinomish*, *Preston*, *Orcas*, *Mamala*, and *Cavanaugh* at an unknown date. Pleasure vessels are tied up below, probably in the 1950s.

Three

THE GARDENS

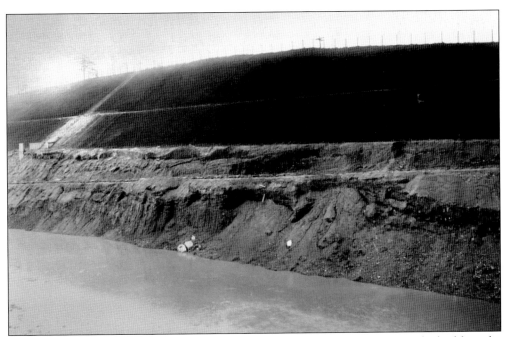

During the construction of the locks, a huge amount of dirt and muck was dug up or dredged from the channel. At the same time, to accommodate all of the equipment needed for the construction site, much of the land surrounding the locks was necessarily scraped bare of vegetation and topsoil.

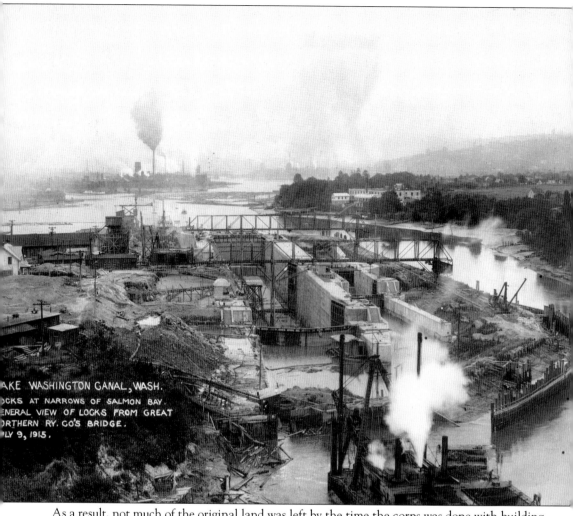

AKE WASHINGTON CANAL, WASH.
OCKS AT NARROWS OF SALMON BAY.
ENERAL VIEW OF LOCKS FROM GREAT
ORTHERN RY. CO'S BRIDGE.
LY 9, 1915.

As a result, not much of the original land was left by the time the corps was done with building the functional part of the facility. The locks worked beautifully, but its locale could hardly be called beautiful. For years, the area around the locks was maintained only minimally. Students from the University of Washington were hired to cut the grass, but little was done beyond that in terms of upkeep of plantings. This photograph shows how unadorned the new facility was. (The picture was taken in 1915, and the area was still quite as bare by the time the locks opened.) The photographer in this case was standing on the bridge of the Great Northern Railway, looking east past the locks. Note the smoke of lumber mills in the background. (Courtesy Julie Albright.)

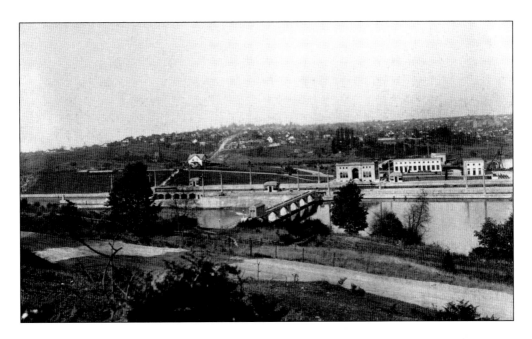

The above view shows the locks from the south shore, looking north to the as-yet undeveloped area around the Administration Building and Cavanaugh House. The photograph below shows how minimally the grounds had been beautified even in 1928, more than a decade after the locks had opened. The number of lumber mills still in evidence surely did not add to the aesthetic pleasures of the neighborhood.

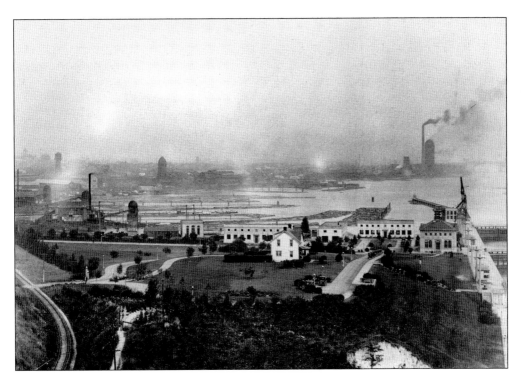

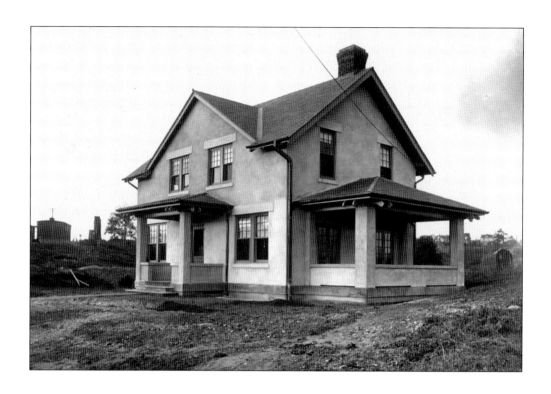

Cavanaugh House (above) is the official residence of the district engineer. The area around it is completely bare, though in time, plantings would surround it completely. The photograph below from 1916 is looking west over an austere landscape with only grass and small garden beds.

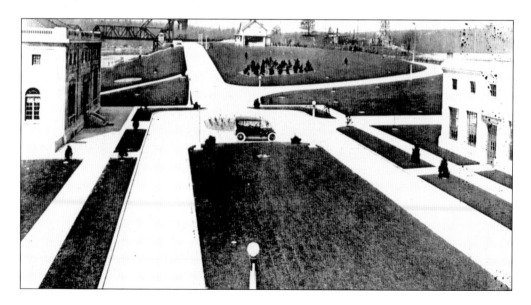

From the beginning, there were plans to further beautify the roughly seven acres on the north side of the locks. Architect Carl F. Gould, who had designed the facility's buildings, created a layout of gardens in 1915, although a full-time gardener, Henry McCarty, was not hired until 1920. Among other achievements, McCarty planted a row of Lombardy poplars on the northern border of the property to create a windbreak. These have since been replaced by redwoods, Douglas firs, and understory plants. But the serious changes did not begin until 1931—the year the Corps of Engineers hired a young man named Carl S. English Jr. as an assistant gardener for the locks. That year, English began his life's work—creating a lush and varied botanical garden on the site. (Courtesy Leah Woog.)

English was born in 1904 and raised on a 240-acre farm in Clark County, in southwestern Washington. He was interested in plants from a young age; at 16, he built a greenhouse, and a high school course in botany led him to specialize in that subject. English graduated from the State College of Washington (later Washington State University) with a degree in botany, and he started his own small seed and plant business before hiring on with the corps. When English began, he had his job cut out for him, but he had at least one positive thing to work with. The area around his future garden was covered with soil dredged from the work site, and this was a rich start. This soil became the base for much of the present gardens.

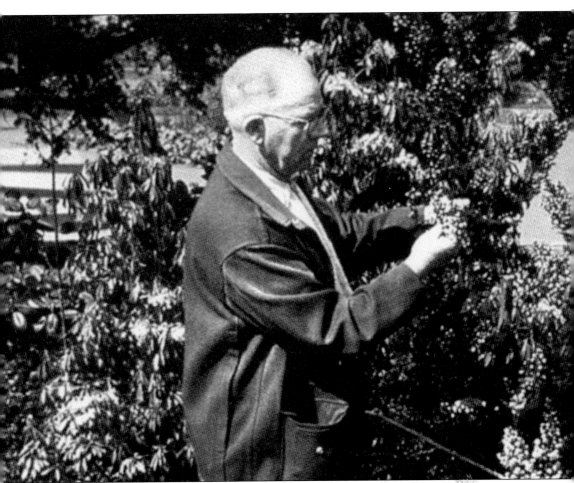

From the beginning, however, English envisioned a diverse collection needing many different soil types. The muck dredged up from the canal was a good start, but it was not enough. Over the next decades, English experimented with various soil amendments to create the ideal environment for each plant. He was promoted to lead gardener in 1941 and in time earned the title of horticulturalist. English, aided by his wife, Edith, broadened the scope of the gardens considerably over the years. He collected many samples on his own travels—he and Edith loved to hike and camp. He also often made deals with ship captains bound for exotic locales, arranging to have them bring back seeds. (The Englishes had wide interests; she was a dog trainer, and the couple also kept species of African toads.) English was thus able to cultivate dozens of plants and trees from many faraway parts of the world. By 1969, he had replaced about 80 percent of the original plant material with a wide array of rare or botanically interesting plants.

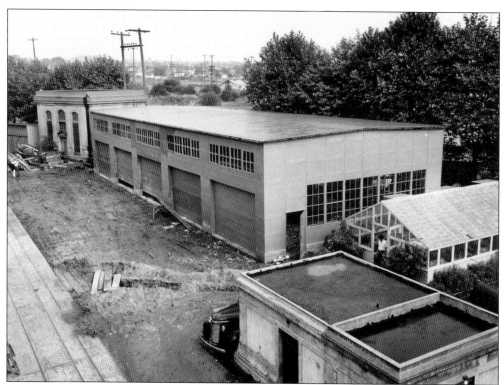

These shots of the locks' maintenance buildings, including the greenhouse, probably date from the 1940s or 1950s. The increased amount of greenery can already be seen. The photographs demonstrate how English's influence was slowly but markedly affecting the locks' surroundings.

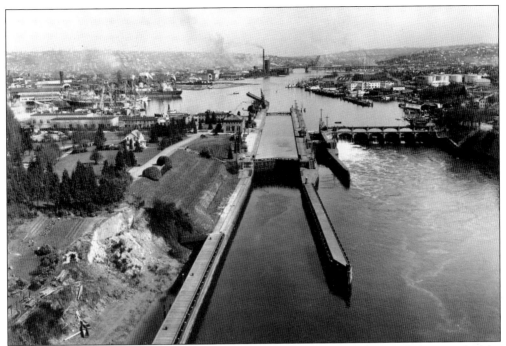

English's growing influence on the landscaping can also be seen in these aerial photographs (the main area of work is the triangular area clearly seen in the lower photograph). The first of these pictures is from 1948 looking east; the second is undated.

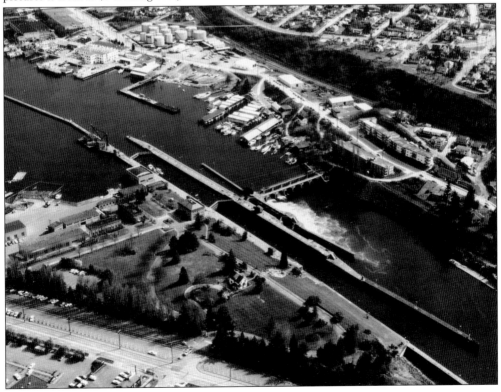

Transforming the landscape was a slow and painstaking process, involving patience and considerable trial and error. By 1962, however, when these pictures were taken, the grounds were beginning to look much different.

In the above photograph from February 1969, Carl S. English is seen receiving an award from district engineer Col. R. E. McConnell as supervisor Ralph Follestad looks on. Below, a tour of the gardens is in progress in August 1969.

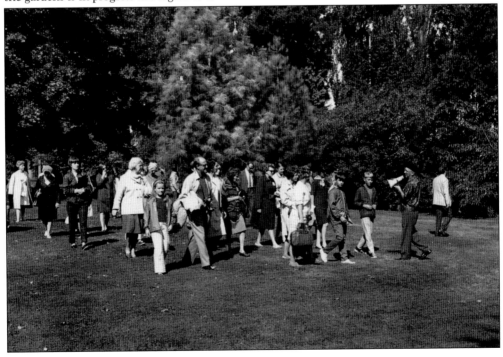

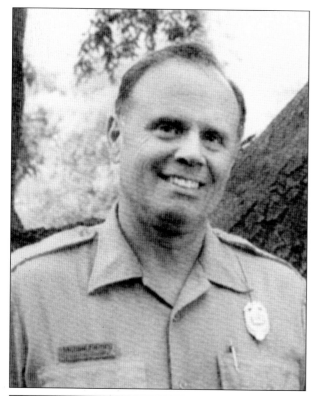

Horticulturalist Michael Fleming (left) took over in 1974, and he did much to expand and maintain the gardens. The gardens' nursery is named in his honor. Among the others who have made significant contributions to maintaining the gardens over the years are Brian Carter, Walt Lyons, and Michelle McMorran. The 1980 photograph below is of gardeners Libbie Soden (left) and Barbara Engler at work in the greenhouse.

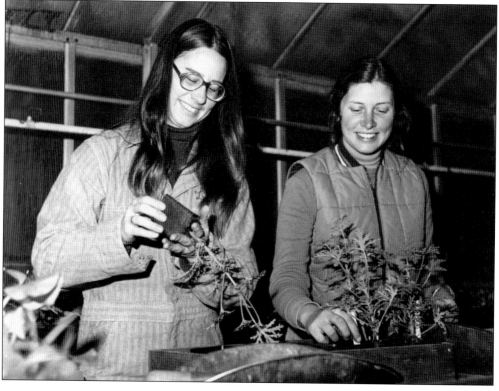

The seven-acre gardens' major collections include significant numbers of roses (above), dogwoods, cherries, magnolias (below), rhododendrons, ginkgoes, fuchsias, and maples. English was especially fond of oaks, and he labored hard to assemble a major collection of these trees. (Above, courtesy Leah Woog.)

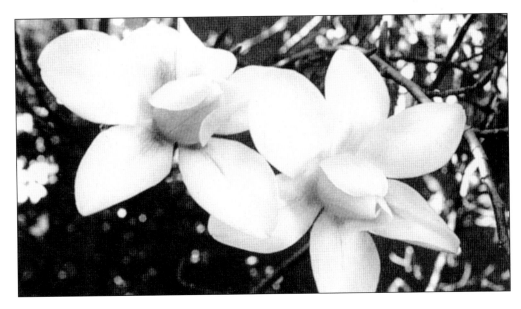

Even in winter, with a rare dusting of snow, the gardens are worth visiting. Seattle's mild climate for most of the year allowed English to cultivate specimens usually seen in tropical climates, such as certain palm trees. In fact, the climate at the locks is even more temperate than elsewhere in Seattle; some flowers and trees bloom there earlier than elsewhere around town. (Left, courtesy Leah Woog.)

In a 1972 article for *American Horticulturalist*, Carl English wrote, "An effort is made to have something of interest at all times of the year beginning with the winter-blossoming shrubs, then the spring abundance of blooms of both tress and shrubs, followed by the summer bloom of the annuals and the late-blooming trees and shrubs, and closing with soothing colors of the autumn leaves." By the time he retired in 1974, Carl English had become one of the Northwest's leading horticulturists. He passed away in August 1976 from an apparent heart attack—appropriately enough, he had been chopping wood in the gardens he had spent so much time, love, and effort to create and which are named in his honor. (Courtesy Leah Woog.)

The gardens boast many unusual trees, including beautiful sequoias, a unique hybrid of a horse chestnut tree and a Midwestern buckeye, and some of the country's oldest dawn redwoods. During his years of work for the Corps of Engineers, Carl English discovered and named three rare plants: *Talinum okanoganense* (fameflower); *Lewisia rupicola* (Lewisia columbiana); and *Claytonia nivalis* (spring beauty). Since these are not suited to Seattle's climate, they are not represented in the gardens. (Above, courtesy Leah Woog.)

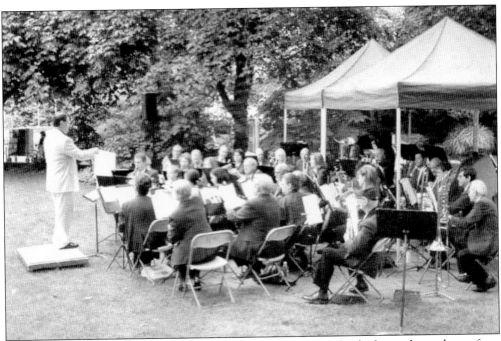

During weekends in the summer, a wide variety of musical groups play for free at the gardens—from gospel, Dixieland-style jazz, and brass bands to traditional music reflecting Ballard's Scandinavian heritage—not to mention a perennial favorite, the Ballard Sedentary Sousa Band. Above is the Boeing Employees' Concert Band, while below is seen the Coal Creek Jazz Band. (Above, courtesy Tom Dean and the BEC Band; below, courtesy Leslie V. Unruh and the Coal Creek Jazz Band.)

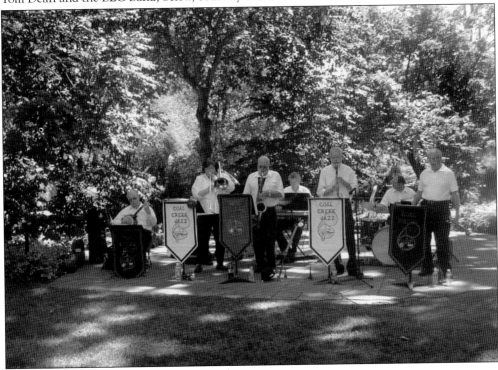

Summer is not the only good time at the gardens, however. Visitors are welcome to admire the horticultural art and science of English and his successors in any season. (Most of it is wheelchair accessible.) Visitors can help preserve the area for future generations by taking only photographs and memories—not plants. The red horse chestnut is at left. (Below, courtesy Leah Woog.)

Four

THE FISH LADDER

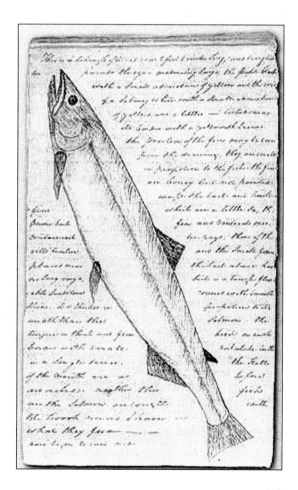

Salmon have always been vital to the Pacific Northwest's ecosystem. They remain a powerful symbol, even as their numbers have dwindled from bountiful millions to an endangered few. Pictured is a sketch from the journals of Meriwether Lewis.

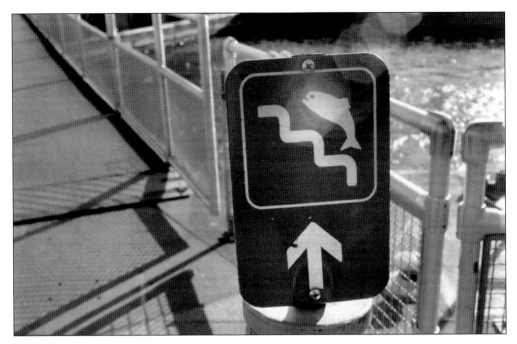

The fish ladder at the Ballard Locks was built to help preserve those salmon originating in Lake Washington's watershed. It is unusual in being only one of three such ladders in the United States located where salt and freshwater meet. Signs with the international symbol for "fish ladder" point the way above. The fish ladder is located across the spillway dam (seen below) from the big and small locks. This dam controls water level in the lakes with gates that are constantly adjusted to keep the level at about 20 feet. (Both courtesy Leah Woog.)

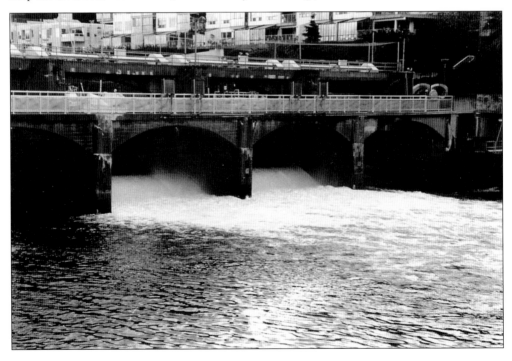

Chinook: ocean phase	Chinook: male - freshwater phase	Sockeye: ocean phase	Sockeye: male - freshwater phase

Coho: ocean phase	Coho: male - freshwater phase	Steelhead: ocean phase	Steelhead: male - freshwater phase

Fish ladders let anadromous fish return to their spawning grounds. Anadromous fish hatch and partially grow up in rivers and streams. They journey to the sea to mature and spend most of their adult lives. Near the ends of their life cycles, surviving fish return to spawn in the streams where they hatched. Not many do survive—less than one in 1,000 survives to spawn. The anadromous fish commonly found at the locks are sockeye, chinook, and coho (all types of salmon), as well as steelhead (oceangoing trout). These fish migrate through the locks from and back to the 500-square-mile Lake Washington watershed. The populations include both wild and hatchery-raised fish. Their numbers vary greatly from year to year, depending on weather conditions and many other factors; once in the millions, their numbers are dramatically lower now. The passage of fish was not a major consideration when the locks were constructed. The emphasis was clearly on creating a channel for vessels and on maintaining water levels in the lakes. Nonetheless, a 10-step ladder was built on the south side of the spillway dam in the original design.

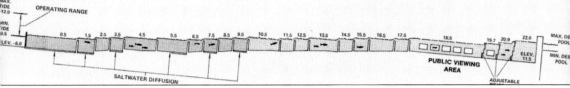

In 1976, the Corps of Engineers renovated and improved this ladder to reflect changes in fish conservation. The most significant improvement was doubling the number of steps, or weirs. The ladder now has 21 weirs, each about one foot higher than the previous—a much shorter jump than in the original. This arrangement allows fish to swim upstream on a very gradual incline. (The ladder incorporates several right-angle turns not shown in the diagram.) Three weir gates control water into and out of the ladder, and a diffuser well mixes saltwater in gradually with freshwater through the last steps. This mixture of saltwater with fresh lets fish gradually adjust to a new environment as they come in from the sea. Another change involved greatly increasing the amount of attraction water flowing through the locks. Attraction water is water that moves swiftly against the direction of the fishes' migration upstream, at the bottom of the channel. In the attraction water, fish can sense precisely which portion of the stream comes from the exact tributary that was their first home, even though that water is mixed with that of other tributaries.

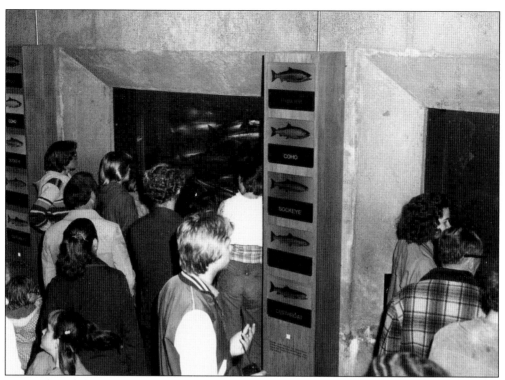

Part of the fish ladder, along its elongated 18th step, is open to the public. Six lighted windows in a special viewing room give visitors an underwater view of migrating fish. The viewing room has explanatory audio-visual help in identifying the kinds of fish seen through the windows. Seattle school kids have decorated the walls with art depicting sea life. (Below, courtesy Leah Woog.)

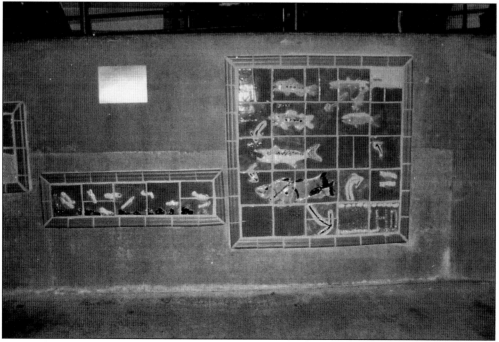

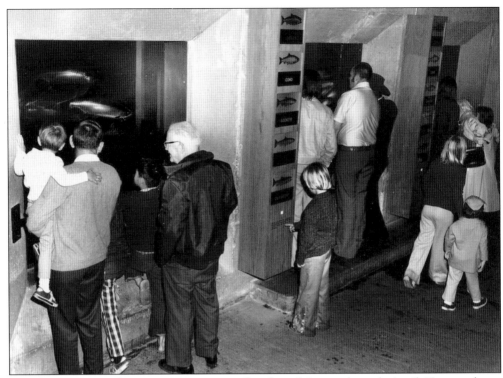

Prime viewing months to see returning steelhead are January through April. Young salmon (smolts) head in the opposite direction, to the ocean, during May and June. But the best seasons for viewing are summer and fall, roughly June through November. This is when salmon return in large numbers.

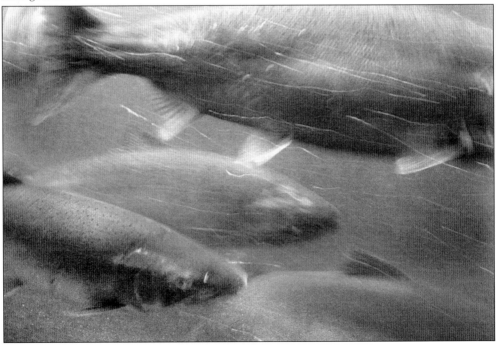

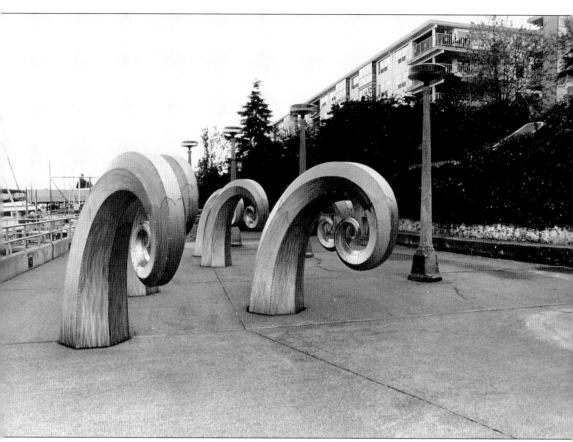

Salmon Waves is a sculpture atop the fish ladder created by Seattle artist Paul Sorey in 2001. The sculpture evokes both the nuts and bolts of the locks' pragmatic construction and the beauty of salmon smolts as they pass through the water. Since glimpses of smolts are fleeting and transitory, the artist uses LED lights to generate quick images of the tiny fish at night. (Courtesy Leah Woog.)

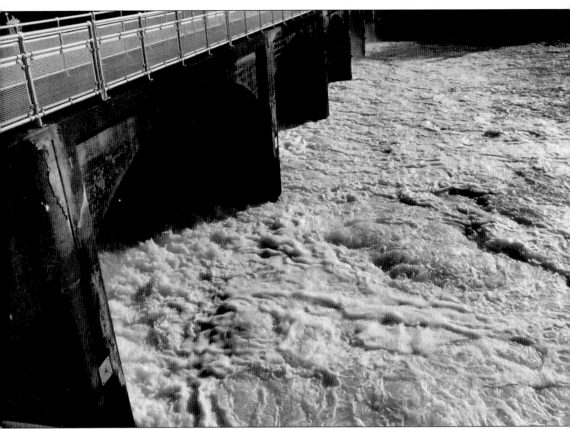

The Corps of Engineers cooperates with a number of agencies to promote a healthy flow of fish through the locks. The most important of these are the Muckleshoot Indian Nation and the Washington Department of Fish and Wildlife (WDFW). They jointly conduct annual counts of migrating sockeye, usually between the second week of June and the end of July. The purpose is to determine if there are sufficient returning sockeye to open fishing season. Fish are sample-counted daily as they pass through both the locks and the ladder and then extrapolated to estimate totals. For example, the forecast for the summer of 2008 estimated 105,575 returning sockeye, well below the 350,000 needed before any sport or tribal fisheries can open.

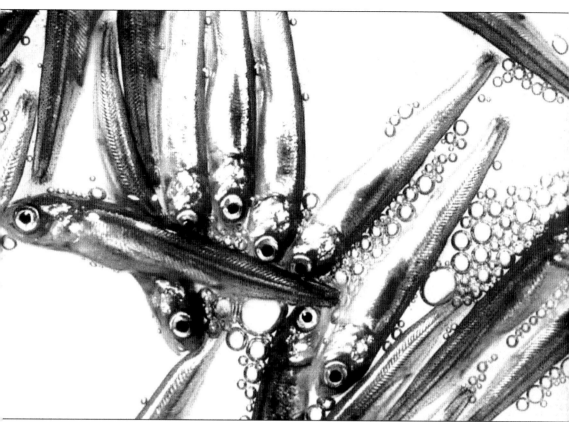

The Muckleshoots and WDFW also collaborate on programs to study returning adult sockeye, collecting information on such topics as age, size, DNA, and sex. This in turn provides important insights into genetic diversity, life cycle, hatchery versus wild identification, survival rates, and other areas critical to fish management. But returning adult fish comprise only half the issue. Young smolts headed to sea are also at risk. Muckleshoot and WDFW scientists found that many smolts were dying each time the locks were opened and closed. Even those that survived were badly battered and stressed. One cause was the abrupt transition from freshwater to saltwater. Another was their passage through barnacle-encrusted pipes at the bottom of the lock chambers, at high speeds, while the chambers were filling. (Courtesy U.S. Fish and Wildlife Service.)

Concerns about smolt survival became especially urgent in 1999, after Puget Sound chinook salmon were placed under federal endangered-species protection. A task force was formed to address this problem with representatives from the WDFW, the Muckleshoot Tribe, the Corps of Engineers, the National Marine Fisheries Service, King County, and the City of Seattle. Out of this task force came a number of changes to make the locks more "fish friendly." For example, the rate at which the large chamber is filled was dramatically slowed, from about four minutes to as much as 20 minutes each time. Also, strobe lights were installed to keep fish away from hazardous culvert entrances as they filled. Both changes resulted in far less stress and injury to the fish. Also, in an effort to provide smolts with a safer alternate route, smolt slides (pictured) were installed in 2007. These open-top steel flumes, seasonally erected and taken down, allow the young fish to glide over the locks in much greater safety. At the peak of their run, the smolt shooting through the slides are so numerous and thick that they look like streams of pure silver.

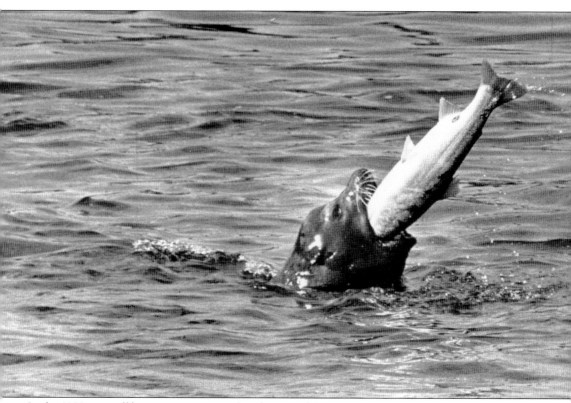

In the 1980s, a small but energetic group of predatory California sea lions, eager for a snack, achieved worldwide fame by frequenting the locks and hoping to snag fish coming upstream. Authorities could not kill them because the predators were protected by the 1972 Marine Mammal Protection Act. The sea lions increasingly devastated fish runs, and in 1990, a special permit was granted to kill them. However, the creatures proved too popular with the public, which had given them nicknames like Herschel (pictured), Hondo, Bob, and Big Frank. Under intense public pressure, they were spared. Authorities then tried various methods to discourage Herschel and his buddies from hanging around. One method was evacuation to Southern California or the Washington coast. A number of other methods were also tried. These included a "tactile harassment program" (shooting retrievable rubber-tipped darts with a crossbow); "seal bombs" (underwater firecrackers that produced sharp flashes of light); "taste aversion conditioning" (putting bad-tasting lithium chloride capsules in recently killed fish that were fed to the sea lions); and chasing the offenders away with a small boat.

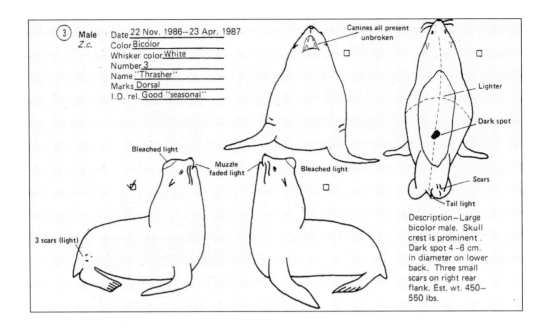

③ Male
Z.c.

Date 22 Nov. 1986–23 Apr. 1987
Color Bicolor
Whisker color White
Number 3
Name "Thrasher"
Marks Dorsal
I.D. rel. Good "seasonal"

Canines all present unbroken

Lighter

Dark spot

Scars

Tail light

Bleached light

Muzzle faded light

Bleached light

3 scars (light)

Description—Large bicolor male. Skull crest is prominent. Dark spot 4–6 cm. in diameter on lower back. Three small scars on right rear flank. Est. wt. 450–550 lbs.

Then there was "Fake Willy," a 16-foot fiberglass statue shaped and painted to resemble the sea lions' only natural enemy, an orca (killer whale). In 1996, a local radio station spearheaded a campaign that raised the $6,000 needed to buy the artificial orca (named in honor of the movie *Free Willy*), have it shipped from Scotland, and anchor it just beneath the water's surface. In the meantime, marine scientists studied the sea lion predation at the locks, a task that included creating detailed "mug shots," such as this one (above), to identify the worst offenders.

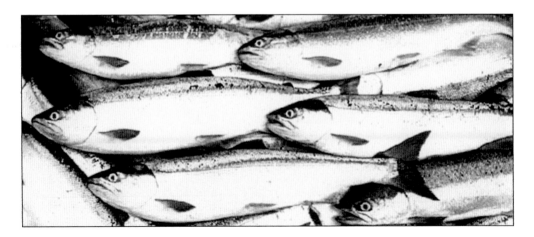

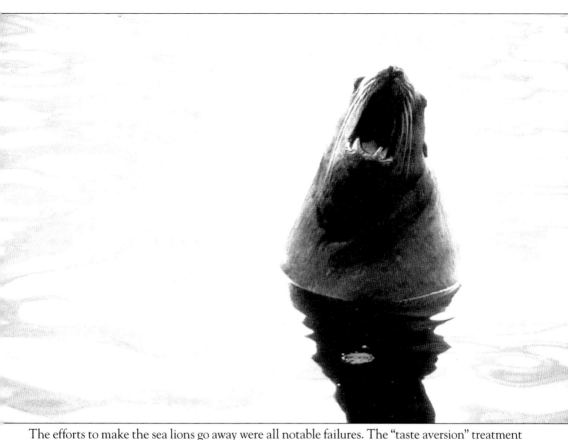

The efforts to make the sea lions go away were all notable failures. The "taste aversion" treatment only made the sea lions slightly ill, and they soon learned to avoid dead steelhead. The predators ignored Fake Willy. Adding insult to injury, many of the exiled sea lions promptly returned to the locks. The only ones guaranteed to stay away were a few that had been sent to Sea World in Orlando, Florida. The sea lions continued to kill off huge numbers of winter steelhead at the locks into the early 1990s—the 1994 run hit an all-time low of only 70 fish. By 1998, however, the problem had solved itself in a way. Most of the sea lions simply left—but only because they had eaten everything they could. Even today, with the predators mostly gone and only a few hopefuls occasionally hanging around the locks, the damage is still noticeable; the steelhead runs have yet to fully recover. (Courtesy U.S. Fish and Wildlife Service.)

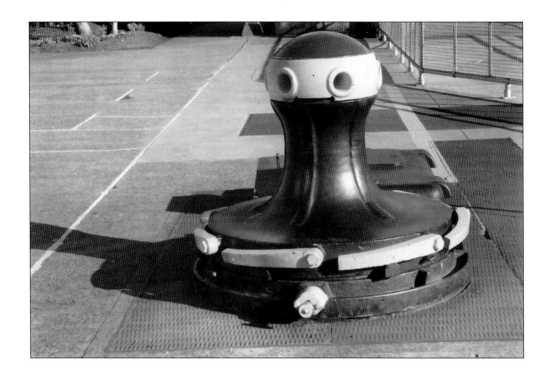

Huge capstans like this one (above) were installed in 1915, when the Ballard Locks were built, as part of a manual backup in case the winding engine failed. They are no longer used, but they have been left in place to remind the facility's visitors of an earlier time in its long history. (Above, courtesy Leah Woog; below, courtesy Julie Albright.)

BIBLIOGRAPHY

Chrzastowski, Michael. *Historical Changes to Lake Washington and Route of the Lake Washington Ship Canal, King County, Washington.* Washington, D.C.: Department of the Interior, USGS, 1981.

Dorpat, Paul, and Genevieve McCoy. *Building Washington: A History of Washington State Public Works.* Seattle, WA: Tartu Publications, 1998.

Ficken, Robert E. "Seattle's 'Ditch': The Corps of Engineers and the Lake Washington Ship Canal." *Pacific Northwest Quarterly*, January 1986.

Freier, Renee L. *Historic Grounds Report—The Carl S. English Botanical Garden.* U.S. Army Corps of Engineers document, 1989.

Gearin, Patrick J., et. al. *Results of the 1986–1987 California Sea Lion–Steelhead Trout Predation Control Program at the Hiram M. Chittenden Locks.* NOAA and Washington Department of Wildlife document, 1988.

Larson, Suzanne B. *Dig the Ditch!* Boulder, CO: Western Interstate Commission for Higher Education, 1975.

Seattle District Corps of Engineers, U.S. Army Corps of Engineers. *Lake Washington Ship Canal Historic Properties Management Plan.* Washington, D.C.: U.S. Army Corps of Engineers, 1998.

Warren, James R. *King County and Its Queen City, Seattle: An Illustrated History.* Woodland Hills, CA: Windsor Publications, 1981.

Willingham, William F. *Northwest Passages: A History of the Seattle District U.S. Army Corps of Engineers, 1896–1920.* Washington, D.C.: U.S. Army Corps of Engineers, 2006.

ACROSS AMERICA, PEOPLE ARE DISCOVERING SOMETHING WONDERFUL. *THEIR HERITAGE.*

Arcadia Publishing is the leading local history publisher in the United States. With more than 4,000 titles in print and hundreds of new titles released every year, Arcadia has extensive specialized experience chronicling the history of communities and celebrating America's hidden stories, bringing to life the people, places, and events from the past. To discover the history of other communities across the nation, please visit:

www.arcadiapublishing.com

Customized search tools allow you to find regional history books about the town where you grew up, the cities where your friends and family live, the town where your parents met, or even that retirement spot you've been dreaming about.